LOST
TOWNS OF
EASTERN MICHIGAN

ALAN NALDRETT

THE
History
PRESS

Published by The History Press
Charleston, SC 29403
www.historypress.net

Copyright © 2015 by Alan Naldrett
All rights reserved

First published 2015

Manufactured in the United States

ISBN 978.1.62619.778.7

Library of Congress Control Number: 2015932931

Notice: The information in this book is true and complete to the best of our knowledge. It is offered without guarantee on the part of the author or The History Press. The author and The History Press disclaim all liability in connection with the use of this book.

This book is dedicated to my partner, Lynn Keck Lyon, who accompanied me on many trips down country roads and voyages off the beaten track, searching for remnants of eastern Michigan's lost towns and the occasional related tale or two.

CONTENTS

WHERE DID EVERYONE GO?

W hat is the allure of ghost towns, lost settlements and extinct villages? For most people it's the mystery involved—where did everybody go? Why did they leave? Why did they build a lot of buildings and then abandon them? The unexplained and unknown have an enchanting quality, and lost towns are no exception. Whether it's the lost continent of Atlantis or an abandoned luncheonette the next town over, it makes one speculate about what happened to cause its present state of desertion.

There are many reasons for an area to become de-populated. Some of these are natural disasters, such as the Great Fire of 1871 or the Great Thumb Fire of 1881, which caused the extinction of many up-and-coming towns.

In Michigan, one of the main reasons for a town to close was the failure of its main business. For instance, in the Saginaw Valley and Upper Peninsula, the lumber business created many temporary "sawdust cities." When the trees died out, the town did, too.

Transportation was a big factor in the growth or stagnation of an area. Michigan is surrounded by the Great Lakes, and shipping by water was how people and goods got from one place to another. When the railroad came along to move products from place to place, many port towns that depended on shipping declined. Likewise, many settlements died when they were bypassed by a railroad or major highway.

In some cases, disease wiped out most of a village and the remaining villagers abandoned the area, leaving little behind. For example, when white

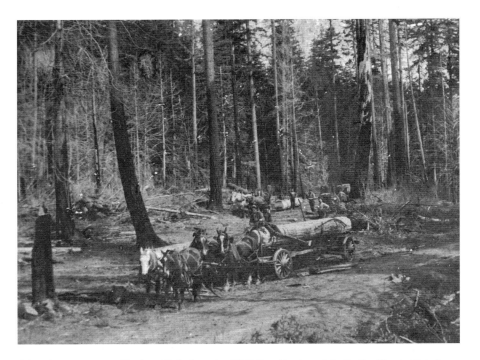

A logging camp near Deckerville before the 1881 fire. *Courtesy of the Sanilac County Historic Village and Museum.*

men moved to an area, they brought diseases with them (such as smallpox) that the Native Americans had no immunity to. Whole villages caught smallpox and died.

Many villages owed their existence to their post office. Farmers would travel to a town to pick up their mail and supplies. In 1896, the U.S. Congress established Rural Free Delivery. RFD, as it was called, slowly became established and spread throughout the nation, and consequently, many of the little village post offices were closed. In many cases, this caused the village to gradually disappear. By 1917, RFD service had been extended to most of the rural areas of the United States.

A big determinant for the longevity of a community was the cohesiveness of the people and how well they got along with one another. Besides depending on one another for obtaining goods and services, the more closely knit communities had group activities. These included quilting and sewing bees, husking bees, house and barn raisings, big game hunts, apple pairings, athletic contests and square dancing done to the accompaniment of a fiddle (and whatever other instruments could be rounded up).

PREFACE

The beginnings of many of the Michigan villages were similar. Often, someone would build a sawmill on the river, or a railroad company would need a stop and so would build a depot in an undeveloped area. A lumber or mining company would move to an area and build temporary housing for workers. To serve the workers of these lumber and mining towns of the 1800s and early 1900s, blacksmiths and farriers would come to care for the horses, the main transportation of the day. Around the same time, a general store would be built, with its groceries, tools, kerosene and lamps, blankets, candles, seed, cracker barrel and pot-bellied stoves and other essentials of early pioneer life. Other businesses would follow in short order. A hotel or boardinghouse (since travel of the day would often require a layover stop), a saloon and perhaps a hardware store would be next. After that, as the settlement grew, there would be bakeries, wainwrights, meat and grocery stores, drugstores and leather goods merchants. Schools and churches would form. Shoe and boot stores would open, as well as tinsmiths, who would make pots and pans and tin roofs.

Most settlements would have a small cemetery about a half mile to a mile from the town. Many times, these cemeteries are all that remain of the community. The small-town cemeteries were commemorated by poet John Greenleaf Whittier when he wrote "The Old Burying Ground," which begins:

Our vales are sweet with fern and rose,
Our hills are maple-crowned;
But not from them our fathers chose
The village burying-ground.

Most of the surrounding land, if not being mined for its minerals or having its trees sold for lumber, was used for farming. "Farmer" was the occupation most often listed on census forms of the day. Most farming communities had a creamery nearby where dairy farmers could sell their milk. The creamery would separate the cream from the milk and sell products such as butter and ice cream. Also in a village there might be a grange, where the farmers could buy and swap seeds and learn new methods of fertilization, as well as receive other agricultural information to increase crop yields and boost soil productivity.

There were a lot more small settlements, villages and towns back in the 1800s and early 1900s than there are in modern times. One of the main reasons for this was transportation needs and limitations. Because roads were so bad—muddy in the spring, sometimes so snow-filled as to be impassable

in the wintertime—it was not easy to get out to get food, heating fuel and other necessities. So small businesses sprang up a lot in small settlements since people couldn't just jump in the car and go to the mall when they needed bread or milk like nowadays—they needed a place they could walk or ride a horse to!

Riding a horse or using a horse and buggy were the time period's transport options; therefore, just as we have auto service stations today, one of the first businesses to open in a new settlement would be a blacksmith shop (sometimes called a farrier) to maintain the horses. There would often be a livery for the horses, and a harness and tack shop selling horse accessories like saddles and bridles. Even very small settlements had a blacksmith, and sometimes even two! So important was the blacksmith to small-town culture that probably one of the best-loved poems of days gone by is "The Village Smithy," written by Henry Wadsworth Longfellow:

> *Under a spreading chestnut-tree*
> *The village smithy stands;*
> *The smith, a mighty man is he,*
> *With large and sinewy hands;*
> *And the muscles of his brawny arm*
> *Are strong as iron bands.*

A trademark of Michigan small towns was a mill of some sort, using the cheap and abundant water supply to power them. There were gristmills to process grain, sawmills for cutting lumber (cut by "sawyers"), sorghum mills, shingle mills and cider mills. Since travel was hard and slow, many settlements would have a hotel or inn with accommodations for overnight travelers.

A post office would open in a general store, grocery store, hotel or inn or sometimes even in a tavern. After more growth for a community, the post office would receive its own building.

There are many reasons a community disappears. Some villages existed in name only—a village might be platted out but the lots never sold. This was known as a "paper village." This included Macomb County's **Genoa**, which was a village that never was. In 1837, it was platted and named Genoa by John N. Draper. Consisting of 192 fifty- by one-hundred-foot lots in Armada Township, it was conceived but never existed except on paper. Another was **Frankfort** (for Frankfort, Germany), which was a settlement laid out in 1837 at Twenty-one Mile Road and Tilch Road in Clinton Township in Macomb County. Its 400 lots were platted along

broad streets with a center marked "extensive salt spring" on the maps. However, there was no salt spring, and no village developed. Still another was **Liverpool**, which was named for its British counterpart in the hopes it would become a port comparable to the original.

Liverpool was platted in 1856 by Edward H. Shook, and he also built a dock and hotel. It was located on L'Anse Creuse Bay in Harrison Township at roughly the intersection of Shook and Jefferson Streets in Macomb County. Unfortunately, the community never took off and so was not able to take advantage of being named after the Beatles' birthplace.

Another way a village disappeared and lost its identity was when it was absorbed into a larger city. Many thriving villages were swallowed up by Detroit—some were annexed by voting and some by eminent domain. Other Michigan cities that annexed settlements include Flat Rock in Wayne County; Macomb County's Warren, Richmond, Mount Clemens and St. Clair Shores; and Thumb-area towns Saginaw and Bay City.

The number-one cause of lost towns in Michigan's Upper Peninsula was the rise and fall of mineral mining, mostly copper and iron. Towns such as Hecla became big until the mining operations stopped. In most cases, this was due to the particular vein of copper or iron running out. As the mines closed and the people left, the village buildings and the settlements that were left behind became ghost towns.

Michigan was settled much later than the other states around it. This was mainly due to the stories spread by early explorers that the land was all marshes and swamps, populated by mosquitoes and savage Native Americans. For over a century the only inhabitants of the area other than the Native Americans were the French Voyageurs, who, in the 1600s, would travel the Great Lakes around Michigan pursuing the fur trade.

It took explorations and subsequent good reviews by Governor Lewis Cass and easy transportation via the opening of the Erie Canal in 1825 to finally lure permanent settlers to the Great Lakes State. In retrospect, it seems strange that the state surrounded by water, in an age when water transportation was the gold standard, was one of the last to be settled. That being the case, many would-be settlements had to compete with the settlements of much more populated states and the amenities that went along with that. Many lumberjacks or miners would come to the state, plan on making quick bucks until the minerals or lumber ran out and then go back to the more "civilized" areas to settle down. The lumber and mining villages were known as wild and rowdy establishments, not places in which you would want to establish permanent residence and raise a family.

Consequently, Michigan has many more ghost towns and villages that have vanished than most other states. There were hundreds, although many were just train whistle stops or four corner burgs with a post office. The more notable ones are the ones that had large populations or lasted a long time before businesses started closing and people moved away. The more dynamic ones are the ones that are out in the middle of nowhere and still have some of the original buildings left. Most of the lost towns only have an occasional foundation, holes in the ground (which were the cellars of the buildings), some railroad ties, grown-over roads and sidewalks and probably, somewhere within a mile, a cemetery. Some have absolutely nothing left that would indicate a town once existed there—they have become totally extinct.

There are three different tiers of lost towns. First are "shadow villages." These villages still have a little life to them. There are still some businesses left on Main Street and maintained residences in the area. Next are the true ghost towns, towns where there is virtually no human activity, only abandoned buildings. Last are the towns where there is no trace left of the settlement. Examples of each type of lost village will be explored within the various chapters.

There are many stories that go along with the lost towns, shadow villages and extinct settlements of eastern Michigan. Turn the pages to find out about them!

ACKNOWLEDGEMENTS

I would like to thank my editors, David A. Castle and Gail M. Zabowski; the people at History Press, including Danielle Raub, Katie Parry and Krista Slavicek; the Sanilac County Museum, including Jeffrey Pollock, Reverend William Moldwin, John Haman and historians Cynthia Donahue and Terry Goike; the Ray Township Historical Society; Don Harrison; Craig Maki; Ron Naldrett; Don Green; Karl Mark Paul; Suzanne Pixley; Mike Regan; the Burton Historical Collection; Paul Torney; Bob Mack; and Richard Gonyeau. Their help was very much appreciated!

DEATH BY ANNEXATION

LOST TOWNS WITHIN THE GHOST TOWN OF DETROIT

The city of Detroit, which is over three hundred years old, is a special case in the annals of lost towns and vanished settlements of the Great Lakes State. With over 700,000 people still residing within its borders, it can't be called a ghost town. But with rows of empty business buildings followed by abandoned houses, many neighborhoods look like what most people believe a ghost town would look like. The general conception of a ghost town is of a place in the middle of nowhere that is completely deserted—there might be a few buildings left, maybe an old school, a church and a cemetery. But Detroit, within its many blocks of abandoned businesses and burned-out residences, could be aptly called an urban ghost town. This is a phenomenon shared by Flint, Michigan's other automotive city. Both of these cities suffer from the usual afflictions that eventually doom other towns—businesses moving out without new ones moving in, causing other businesses to close or relocate and people to follow the work. This causes declining population and, eventually, empty and abandoned buildings.

This is especially ironic in the case of Detroit, which, in its growing stage, absorbed many otherwise independent, self-sustaining and thriving communities. Now Detroit struggles to provide basic services, such as streetlights and garbage pickup, to its many outlying areas. And Detroit has a lot of space to service—within the area of Detroit you could fit the cities of Boston and San Francisco and the borough of Manhattan.

The former communities of Detroit are different from most lost villages in that the villages at one time were thriving and felt growth would be more

dynamic if they were part of a major city. Unbeknownst to them, that major city would gradually decline over the next century.

Base Line (or Baseline) was located just north of Eight Mile Road (known as Baseline Road on the west side of Detroit). The square-mile settlement was platted and recorded on November 2, 1860, and named Base Line because it ran over the approximate location of the surveyor base line for Michigan. It was given a post office on April 25, 1927 (George P. Siagkris was the first postmaster), which lasted until July 31, 1957. Siagkris built the first two-story brick house in the area. The first floor was the post office and stores; the second floor had offices occupied by the first doctors and dentists in the area. The settlement was governed under the township until annexed by Warren in 1957.

In 1872, **Beech** was a small hamlet of about seventy-five people on the outskirts of Detroit. It was a stop on the Detroit, Lansing and Lake Michigan Railroad and had a railroad office, a general store and its own post office. The Dunning, Fisher & Rhode steam sawmill made oak railroad ties. One of the most highly regarded schools in the area started operating in Beech in 1874.

Businesses of Beech included the Fisher General Store, which included the Beech post office as of 1871, and proprietor and postmaster Albert Fisher also had a sawmill. The train stop was originally called **Fishers Station**, and the village was also known as Fishers. There was a clothing store, telegraph office and the blacksmith business of Charles Guttman. Other businesses were the Prindle Hotel, the shoe and boot store of Charles Ruppert, and the creamery of G.W. Towar, who owned all the pastureland along Beech Street between the railroad and Schoolcraft Street. He later sold out to Detroit Creamery, which eventually sold out to Borden's.

Beech was absorbed by the village of Redford, and then in 1906, it became part of Detroit. Beech Street still exists within Detroit in the area of the former village.

Not far from Beech was **Bell Branch**, which was one of the earliest villages of Detroit—starting up in 1813. Bell Branch was named for settler Israel Bell, brother of Azarias Bell, who organized the village of Redford in 1818. Bell Branch was located at Twelfth Street, now Fenkell Street, and at Bell Branch Road. Bell Branch Road was renamed Telegraph Road. The village was on the Rouge River, and its first post office was opened in 1877. It was close to what was then called "the Plank Road" before it was renamed Grand River Avenue.

Glue and chair factories were located in Bell Branch around 1860, as well as a school and a Baptist and Methodist church. It was a stop on the Detroit,

Lansing and Lake Michigan Railroad until, because of the narrow tracks that caused sparks, the train stopped going to Bell Branch. To replace it, there was a daily coach that traveled from the railroad station to the nearby Beech stop. Bell Branch also had a blacksmith and a general store.

In 1899, the population was over two hundred. A cemetery on Telegraph between Fenkell and McNichols Streets carries the Bell Branch name. Also known as Redford Center because it was located in the center of Redford Township, the whole area was absorbed by Detroit in 1907.

In the Roaring Twenties, **Brightmoor** was more of a housing project than a village. In 1921, B.E. Taylor bought 160 acres on Grand River and, in 1922, opened Brightmoor Subdivision. Through sales agents, he brought people from all over the area by bus, wined and dined them, took them around to pick out a lot and then signed and sealed the whole business in a big orange tent within the district. Within twelve days, the houses would be constructed to the new owner's specifications.

The quickly built houses were very popular, so in 1923 and 1924, he added 2,913 more acres. Brightmoor was annexed by Detroit in 1926 and is still a district within the city.

Businesses in Brightmoor included seven hardware stores, an A&P Supermarket, three doctors, a dentist, Jones Drugstore and a pool hall. Uncharacteristically, on the second floor of the pool hall was the home of the Tabernacle Church.

A very early settlement, **Brown's Town**, or **Brownstown**, was named for Adam Brown, who, in 1784, when he was eight years old, was captured by Native Americans in Virginia. He was adopted into the tribe and migrated with them to Michigan. Brown was named a chief by the tribe and was still alive when the War of 1812 Battle of Brown's Town happened.

Brown's Town had a post office starting in 1825 with John Sturgis as the first postmaster. The village was located at the nexus of the Detroit and Huron Rivers in Wayne County. In 1925, the post office was transferred to become part of Flat Rock.

Conner's Creek was a village established in the late 1700s. Conner's Creek was at first called Trembly's Creek after Joseph Trembly, who received a U.S. land grant for 640 acres where the creek crossed Fort Gratiot Road. As Moravian missionaries and others came through the area, a road with a log church and a mill by the creek were built. Richard Conner married Joseph Trembly's daughter, Theresa, and the area became known as Conner's Creek.

In 1832, German settlers built St. Mary's in the Woods, which later became Assumption Grotto Church, the second oldest in Detroit. It is on Gratiot

Avenue near Mapleridge Street in Detroit. They went there because they were told to avoid the Detroit area, where a cholera epidemic was occurring.

In 1853, an official village was laid out. A post office operated from 1855 until 1907 and was centered at Gratiot and Greiner Streets. From 1893 to 1899, the village was called Greiner for Michael Greiner, whose estate covered hundreds of acres in the area. In 1917, the village, with over two thousand in people, voted to become part of Detroit. By 1928, Conner's Creek itself, which had once been navigable down to the Detroit River, disappeared beneath subdivision drains. Today, the location of what was once the village of Conner's Creek is under Detroit City Airport. The names of Conner and Greiner are still commemorated in street names in the area.

Delray was one of the villages absorbed by Detroit in the early days and was first platted as Belgrade in 1836. It was renamed Del Rey, Spanish for "of the king," in 1851 and later Anglicized to Delray. A town founded before Michigan became a state, it received a post office in 1870 and incorporated as a village in 1897. The city of Delray Beach in Florida was named for Delray.

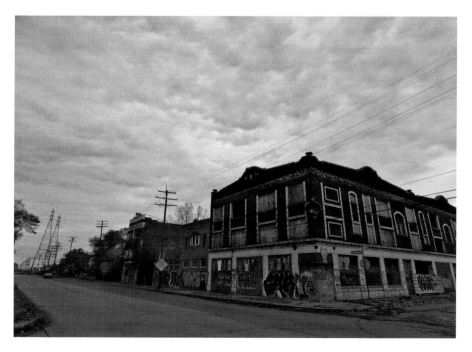

The streets are empty and the buildings are abandoned in this former business area of Delray. *Photo by the author.*

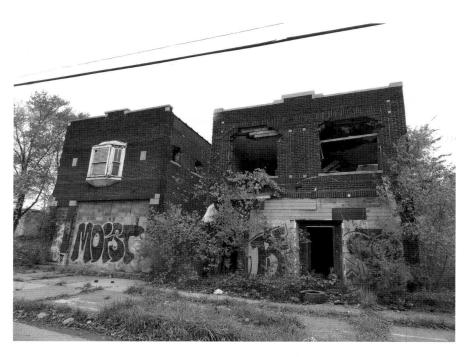

The area of Delray, once independent of Detroit, is now a part of the city that is becoming akin to a ghost town. *Photo by the author.*

In 1894, the Solvay Process Company opened a chemical plant and added paved roads and fire service to Delray's infrastructure. Soon more chemical companies and factories came to the area, giving the village an industrial feel. As more chemical companies moved in, more individuals moved out. In 1906, the independent village was annexed by the city of Detroit. In 1939, a wastewater plant was built in Delray and many houses were torn down—also when the plant expanded in 1957 more houses met the wrecking ball. When Interstate 75 was routed through the area in the 1960s, more dwellings were destroyed, and Delray became a shadow of its former self. In the decade of the 2000s, most of the remaining local businesses closed until Delray became a lost town within the ghost town of Detroit.

Duboisville was a village built around Jacob Dubois's lumber mill in 1850 on what is now the west side of Detroit by Seven Mile and Berg Roads. Jacob Dubois had an archrival, a prosperous merchant by the name of Julius Ziegler, who wanted the town named Zieglerville for him. But Dubois prevailed, and it was known as Duboisville for as long as it lasted.

On Sundays, when the mill was closed, families would picnic on the lawn by a small waterfall there. East of the center of the village was the Duboisville School, an elementary school that kept the town name alive until the 1980s; thereafter, it was a private school.

The village had already started its decline by 1900, and when the Duboisville Mill closed in 1916, its demise continued. It joined Sandhill to become part of the village of Redford and, eventually, by village vote, was annexed as part of Redford to Detroit in 1926.

The area of Duboisville became the site of the last amusement park, Edgewater Park, located within the city limits. It closed in 1984 and the Greater Grace Temple Apostolic Church has since developed a large complex in the area with a megachurch and senior housing complex.

Eagle Pointe was platted and recorded on May 23, 1916, by Edward J. and Louise M. Hickey. Located on a point of land projecting into Lake St. Clair in Lake Township, this area was absorbed by the village of St. Clair Shores in 1925.

East Saginaw was another sawdust city across the river from Saginaw. In 1850, Norman Little began building East Saginaw, and in 1851, it gained a post office. It was incorporated as a village in 1855 and grew rapidly enough to become incorporated into a city two years later in 1857. It joined with South Saginaw in 1873, and then both became part of the City of Saginaw in 1891.

The people of East Saginaw engaged in a feud with **Bay City** and would often get in heated newspaper diatribes over the matter. The *Saginaw Courier* especially liked publishing reports on the vice and crime in Bay City. A particularly salacious story was about Bay City's town marshal, who was arrested for owning a resort and unofficially "taxing" prostitutes. Another comment was made when vagrants were picked up along the railroads in East Saginaw—the newspaper account said that they were probably all headed to "Tramp Heaven—Bay City."

The Bay City newspapers retaliated by informing readers that East Saginaw was built on a swamp and was a great place to be if you liked flooding, mosquitoes and mud.

Bay City was a sawdust city that was originally built to accommodate the burgeoning lumber industry in Bay County. As a sawdust city, it had a famous salacious side gained from the twenty-six hotels, thirty-seven saloons and two liquor stores located in a four-block area known as the "Catacombs" and "Hell's Half-Mile." Prostitution, drunkenness, brawling, robbery, gambling, cockfights and even murder were everyday

occurrences in the area. There wasn't even a police presence in the area until 1859 when Bay City hired a marshal.

Complaints of "drunken policemen" were common once the police force was activated. The marshal of Bay City was arrested for charging prostitutes a tax to operate, and if it was not paid, a raid on the establishment would occur. The town marshal, D.H. McCraney, was discovered to own his own brothel, a place where he spent most of his off-hours. Interesting was the census of 1880, in which many of the occupations of known prostitutes were given as "laundress," "domestic," "servant" and that old mainstay, "dance-hall girl."

East Saginaw lost its autonomy and fiery newspaper rhetoric when it was absorbed by Bay City in 1889.

Fairview was a village near Grosse Pointe known for its racetracks. Many of the streets in the area, such as Waterloo, Iroquois and Seminole, were named for horses or horse farms. A still existing brick path along Marlborough Street once led to the Detroit Jockey Club, which had one of three horse racetracks in the area. Another horse racing track was known as the Hamtramck Track and was located along Jefferson Avenue by the Indian Village neighborhood of Detroit. The third track was known as the Detroit Driving Club and was along Jefferson Avenue at Algonquin Street. This track allowed automobiles, and Henry Ford raced some of his early cars there.

Fairview was located on the river between Grosse Pointe Park and Detroit. It was an incorporated entity from 1903 to 1907. The Fairview Land Company formed in 1896 with nine hundred acres of marshland to develop, which it did with the help of the road being built from the Grosse Pointes to Detroit. The boundaries of Fairview were Bewick Street to the west, Cadieux Street to the east, Mack Avenue to the north and the Detroit River to the south.

As the City of Detroit more deeply invested in the rail system it owned, it voted to annex Fairview in 1907 in order to get some prime routes and force out competitors. A representative from the Grosse Pointes requested two miles near the shoreline, which became Grosse Pointe Park. Fairview and its township, Grosse Pointe Township, were annexed and divided by Detroit, with part of the land (from Bewick Street to Cadieux Street) going to Detroit and part (from Cadieux to Alter Road) going to form the Village of Grosse Pointe Park. Grosse Pointe Park became a city in 1950.

Another lost village of the Detroit area was **Five Points**, which was named for the five corners of which it consisted. Each corner had a general store or

other business. It was a west-side village at Grand River, Seven Mile and Five Points Road. Five Points Road, the Detroit boundary on the northwest side of Detroit, was named for this early village that was a stop on the railway. It had a railway station and a post office. The post office closed in 1918, and the town was dying out when Five Points was absorbed by Detroit in 1926.

Forest Lawn, **Mount Olivet** and **Woodmere** were the names of three of Detroit's former villages that left large cemeteries commemorating their village names. Forest Lawn was a relatively small farming community west of Van Dyke Road and south of McNichols Road that was a stop on the Grand Trunk Railroad. Named for the stately trees in the area, it was developed by the Swan and Avery families in 1888 and comprised just 128 acres. A cemetery was added to these acres that, for a long time, were only accessible via the train. The area was absorbed by Detroit in 1907, and the only remainder of Forest Lawn village is the cemetery.

Mount Olivet's beginnings were very similar to that of Forest Lawn's. In 1888, the community began to form around the newly platted Catholic cemetery. The Detroit area's first Catholic cemetery was Mount Elliott, founded in 1841. It was becoming crowded, and new burial grounds were needed. Soon, businesses began to form around the site on Van Dyke Avenue, and it became a stop on the Detroit United Railway (DUR). The area flourished until 1925, when it was annexed by Detroit.

Woodmere is a west-side cemetery, famous as the last resting place of many notable Detroiters, including James Vernor, founder of the original ginger ale; David Buick, founder of Buick Motor Company; and auto magnate Henry Leland. In 1868, as the cemetery grew, a settlement around it did, too. A station on the Canadian Southern, Lake Shore and Michigan Railroad, the area was known for its rich salt deposits. There were salt mines beneath the town and a big soda ash processing company that employed many of the townspeople. It had a post office from 1884 until 1906, when the town was annexed by Detroit.

Greenfield was a village at Detroit's Wyoming and Grand River Streets. It was first settled by John Strong and attracted early German families in the 1840s. A station on the Pere Marquette–Ann Arbor Railroad, its post office was first granted in 1837 and was open until 1857. Afterward, it was open intermittently until 1872. Its businesses included a livery, hotel, church and saloon, and in 1900, it was a stop on the interurban, the Detroit United Railway (DUR). Named for the surrounding green fields, it was a thriving business and farming center until annexed by Detroit in 1924. The name survives in Greenfield Street

The Greenfield church and school building were in the area where Henry Ford spent his formative years. *Courtesy of Don Harrison.*

in Detroit and in nearby Dearborn, where Greenfield Village is a popular Ford museum complex attraction.

Howlett was a hamlet located about five miles from the Detroit city limits in 1896. The Detroit Northwestern Railway went through and stopped in Howlett, which began in the Livernois/Fullerton Streets area of what is now Detroit. It was named for state senator and storekeeper Joseph P. Howlett, who was also the first postmaster in 1899. Howlett had a population of over six hundred when it was annexed to Detroit in 1916.

Lake City was platted in 1863 by Henry W. Sage and was designed to be a company town for Sage, McGraw and Company. With a mill and houses, it attempted to get a post office named Lake City, but due to there being another Lake City in Missaukee County, it was renamed Wenona. Wenona, Salzburg and Banks were incorporated into another city called West Bay City in 1877. In 1905, it was absorbed by Bay City.

Leesville had its origin when Charles Lee founded St. John's Episcopal Church mission church at Gratiot and Butler (now Harper) Streets about 1855. This was the successor church to Lee's Chapel, the Protestant church of choice in the area for many years, with the Catholics going to Assumption Grotto in Conner's Creek. The Episcopal Church of Our Savior was built on the site in 1874 and is still there in 2015.

The town of Leesville was named for church founder Charles (in some accounts Robert) Lee. Leesville was famous for two things—brickyards,

started by the Cooper and Aspinwall families, and cucumber farms. A road in the area was called Cucumber Lane (later changed to Georgia Street). John Cooper opened a brickyard on his farm that went on to provide bricks for many of the village's buildings.

Leesville was a major interurban and streetcar stop, containing the barns that housed the DUR's streetcars in 1903. It contained over one hundred residences and included many large farms. The area was one of the first to get streetlights in 1902 and had its own post office starting in 1872. In 1915, the area was annexed to Detroit, but the area is still known as the Leesville Historic District.

Maybury is not to be confused with Andy Griffith's Mayberry—this one was located east of Center Line (now Van Dyke) Road, about a mile south of North Detroit (Norris) and seven miles northeast of Detroit. The settlement was named for William C. Maybury, who represented the Michigan First District in the U.S. House of Representatives from 1883 to 1887 and was mayor of Detroit from 1897 to 1904. The Michigan Central Railroad had a stop at this crossroads village that had a post office from 1888 until 1892 with storekeeper John Milns as the postmaster. Maybury was annexed by Detroit in 1915.

Nallville picked up its name in 1874 when Dr. Charles Nall platted out the village in Wayne County. It had been a settlement since 1866, when a boot factory was started there on the street still called Nall Street. Dr. Nall was also an author and wrote a few local history books, including a directory of Detroit churches. His namesake village was annexed by Detroit in 1885.

An early village on the River Rouge was **Navarre**, which was named for early French settler Robert Navarre. The Navarre family came to the area circa 1730 from Nova Scotia. Originally from Villeroy, France, the family was related to Henry IV of France.

In 1910, Navarre was incorporated as a village and received its first post office in 1899. It was renamed **Oakwood** in 1918. In 1922, Oakwood was annexed by Detroit.

Norris (North Detroit) was one of the first Detroit-area villages and had a few different names. Norris was also known as **Dalton's Corners** and North Detroit. Its founder, Colonel Philetus Norris, wanted to name it Prairie Mound because of the Indian burial mounds nearby. Mound Road—originally called Center Line Road in that area because it led to the rising village of Center Line—was renamed for the many Native American burial mounds along the road. The Dalton's Corners name was for Lawrence Dalton, postmaster in 1868 and a Wayne County

A nationally registered historic site, the original house built by Philetus Norris, namesake of the village of Norris, at the corner of Mount Elliott and Iowa Streets. *Photo by the author.*

representative. The name of the post office was changed to Norris in 1873 and was changed again in 1891 to North Detroit.

It was 1865 when Colonel Philetus W. Norris brought the property in the Six Mile/Mound Road area and built a log cabin. By 1873, a village had begun to form in the square mile between Six and Seven Mile Roads and Van Dyke and Mound. Norris built his house at Mount Elliott and Prairie (now Iowa) Streets, a house that still stands today, very much the worse for wear.

Colonel Philetus W. Norris was born in Palmyra, New York, in 1821 and, in 1826, moved with his parents to Michigan, where they had purchased eighty acres. Leaving home, he married Jane Cottrell from Ohio and had four children: Edward, Aurelia, Ida and Arthur. At first making a living as a trapper and trader, he was a spy in the Civil War for the North, achieved the rank of colonel and later was the second superintendent of Yellowstone National Park, from 1877 to 1881. After exploring Yellowstone Park, the Norris Geyser, the Norris Pass and the

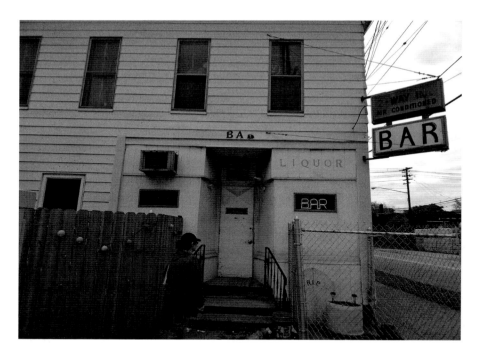

The 2-Way Inn of Norris, a former small town near Detroit, has two ways in and out of each room, which no doubt came in handy. The Norris jail was in the basement of this building. *Photo by the author.*

Norris Overlook were all named for him. He established the park's first conservation officers and has a museum there dedicated to him.

In 1873, he brought his family to Michigan and founded the village of Norris while establishing a real estate business. At first they lived above the 2-Way Inn, a building Norris had built, until completing the family home a block away. He later built a wing onto the house for his real estate business.

The 2-Way Inn, still a thriving enterprise and repository of information regarding Norris, was Philetus Norris's business building. Located on Mount Elliott Road, at various times it was a general store, the village jail (in the basement, basically a lockup until prisoners could be transported to the larger jail in Detroit), the post office, a dentist's office, a dance hall (on the second floor) and a brothel. It is now the oldest-surviving bar in northeast Detroit. It was called the 2-Way Inn because every room had at least two doors so in case of fire or police—or entry of an irate spouse—there was always another way out!

Norris built his village between the forks of Conner's Creek and initiated a vast drainage system of the area while establishing plank roads. He was

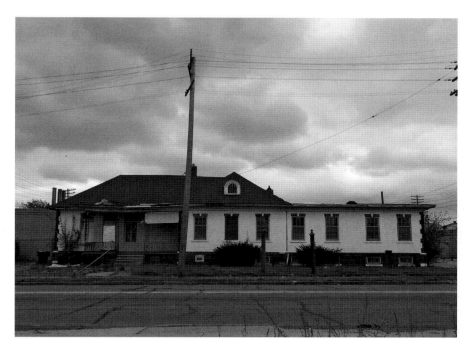

St. Mary's FBH Church (the FBH stood for Fire Baptized Holiness—even better than just water) is pictured. *Photo by the author.*

also an archaeologist and died in Kentucky while digging up dinosaur bones for the Smithsonian Institute.

The 2-Way Inn's current caretakers say that Norris's ghost still haunts his old business building. The ghost wears the buckskins, beard and apparel of a fur trader. The business has been owned and operated by the Aganowski and Malak families for over forty years.

Norris grew and at one time it had a hotel, wagon shops, blacksmiths, a sawmill, a newspaper (the *Suburban*), English and German schools, a railroad depot—the town of Norris was a stop on the Detroit–Bay City Railroad, as well as later railroad lines. Even though Norris was renamed North Detroit in 1891, the railroad stop was still called Norris for years. By 1900, there were over 1,200 residents.

The Miles Orton Circus had its winter quarters in Norris. At one time, the circus was known as the Miles Orton's Mastodon Show and Royal German Menagerie, but it must have had trouble fitting all that on the marquee and became widely known as the Miles Orton Circus, Miles Orton American Circus or the Miles Orton Traveling Circus. Miles Orton was a bareback

rider and originated the "Peter Jenkins Act," where Orton would come out of the crowd, pretending he was drunk, and then proceed to put on an expert bareback riding show. Child endangerment laws today might not have allowed another of his stunts—holding a young child while standing on two galloping horses, one leg on each horse. The other five members of his family also worked in the circus as bareback riders and acrobats. The circus

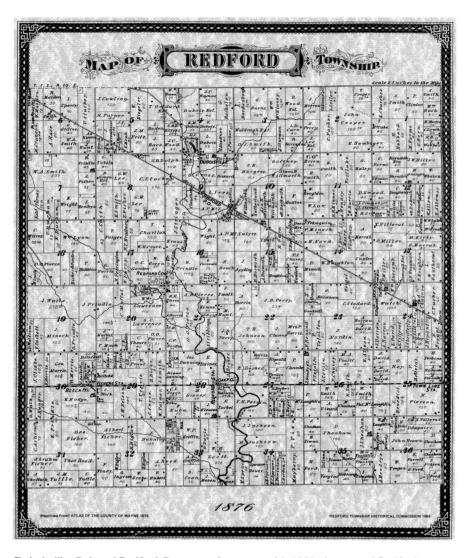

Duboisville, Oak and Redford Center can be seen on this 1870 plat map of Redford Township, before its absorption into Detroit. *Author's collection.*

traveled by rail with many other circus performers, including the riding dog Hector and Lizzie the Performing Elephant.

Another Norris business was the Lutheran (German Evangelical) School for the Deaf and Dumb, a school that moved to Norris when it was given twenty acres by Philetus Norris, complete with outbuildings, on the provision that it move to the village. The school stayed over 120 years on Railroad (now Nevada) Avenue.

German Lutheran farmers were among the first settlers of Norris, using the train line to ship their crops to outlying areas. Besides the Lutheran church, Norris had a Catholic church and St. Mary's FBH Church, whose house of worship, although now vacant, is still there on Mount Elliott Street, down the street from the Norris house and the 2-Way Inn. The "FBH" stood for Fire Baptized Holiness, and the church was an offshoot of the Pentecost sect. "Fire Baptized" was a third blessing, with the first two being salvation and entire sanctification.

The North Detroit name survived as a Detroit Street Railways (DSR) stop until the 1930s. In 1916, the village voted to allow itself to be annexed to Detroit. A remnant of the village is Sirron Street, which is Norris spelled backward.

Oak was a settlement and a station on the Detroit, Grand Rapids & Western Railroad and was twelve miles from the Detroit border on the west side of the city. It had its own post office from 1858 to 1906 and was north of the Rouge River, north of Plymouth Road. Today largely the area of the Rouge Park Golf Course, in 1856, it was the site of a hotel known for its salt baths located on the Old Plank Road that led to the village of Plymouth. Oak was the location for the main school in the area and, by 1880, had a population of 150. By 1906, however, it had gone into decline. The area was annexed by Detroit in 1925.

The village of **Redford** was founded in 1828 by Azarias Bell and at first called **North Pekin** after Pekin Township. It was renamed Redford in 1833. Redford prospered in the Grand and Rouge River area circa 1856 and once covered thirty-six square miles. By 1875, the town center was at the old Lansing Plank Road, renamed Grand River Avenue, and Lahser Road. Streets in the area were named for local merchants, and one thoroughfare, Curtiss Road, is curved due to being the remnants of a racetrack that operated around 1880. The town was known for the Redford Fair, which was held until 1901.

The city of **Richmond** in Macomb County was the uniting of five different settlements. These included **Ridgeway**, **Lenox Station**, **Beebe's Corner**, **Cooper's Town** and **Muttonville**.

The old Redford main drag is still a viable entity within the city of Detroit. *Photo by the author.*

The entrance to Huron City, which got burned in the 1871 fire, was rebuilt and then burnt down again in the 1881 fire. The village has been restored to look as it did back in the logging days. *Photo by the author.*

Ridgeway was a small village on the Richmond/Lenox Township border on the north side of Thirty-two Mile Road along the railroad track—it was called Ridgeway for its high ridge. It was renamed for its adjoining township and given a post office as **Lenox Station** in 1848. Lenox Station annexed Beebe's Corners and was incorporated into Richmond in 1879. Richmond first received a post office in 1840 and was incorporated as a village in 1879.

Beebe's Corners was located roughly at Main Street (Michigan 19) and (Armada) Ridge Road in Richmond, Michigan. It was named for Erastus Beebe, who had government land in northern Macomb County in 1835. In 1855, the aptly named Harvey Wheeler had a wagon (and sleigh) shop here. In 1885, the first hotel was erected by Beebe. With the Grand Trunk Railroad nearby, the settlement grew to include a blacksmith shop, a grocery, a church, a school, two hotels and a general store. Beebe Street still exists in east Richmond and also in a historical village in Beebe Street Memorial Park.

Not far away, down the street from Beebe's Corners at Second Street (now Water Street) and Main, James Cooper built a stave mill. In 1860, he also added Cooper General Store. The area became known as Cooper's Town.

In 1878, Beebe's Corners, Cooper's Town and Ridgeway voted to combine into one entity named Richmond. In 1879, Richmond was incorporated as a village.

Muttonville was located chiefly at the junction of Gratiot Avenue and State Highway 19 in Macomb County. Muttonville was predominantly sheep raising country—hence the name. Founded in 1882, a sheep slaughterhouse was there, with most of the mutton, wool and woolen goods shipped to Detroit via the railroad.

Muttonville was the home base of country/rockabilly singer Lonnie Barron, who had a national hit with the song "Teenage Queen" in 1956. He had just been signed to a major label and national tour when he was murdered by a jealous husband. Barron had many other hits in Michigan and Ohio and was just beginning to break nationally. He wrote a column, "Lonnie's Country Corner," for the local paper, the *Richmond Review*. He lived next to White Eagle Hall, also known as the Polish Cultural Center, on Gratiot Avenue in Muttonville. Barron would rent out the hall for Saturday night dances that he advertised on his radio show on WDOG in nearby Marine City.

On January 7, 1957, Barron returned to his home to find the door open. Inside, drowning a pint of whiskey, was Roger Fetting, who had just found a letter his wife had written to the country singer but had yet to mail. The

letter hinted at an alleged affair between Fetting's wife and Barron. In the small house Barron lived in, Michigan state police found hundreds of fan letters written to rising star Barron.

Later confessing to shooting Barron twice, Fetting received a sentence of five to fifteen years in Jackson Prison due to a clever lawyer's having the charge reduced to manslaughter in light of Fetting acting on "jealous rage."

The venue, the White Eagle Hall, continued to be used for music shows for many years until it burned down in the 1970s. Another proprietor after Lonnie Barron was Bill Keck, who used the hall as a coffeehouse named Blue Shay and then the Pit and booked jazz acts, including the Tempests and Bobby Bongo Bengalis. The venue would draw a mixed crowd, including a contingent of African Americans from nearby New Haven. They would be accompanied by chaperones sent by New Haven benefactor Beatrice "Mama Bea" Perry. In 1989, the area that comprised Muttonville was absorbed into Richmond, which had been incorporated as a city in 1966.

Riverside was a very early area that encompassed six square blocks on the riverfront between Fort Wayne and the Ambassador Bridge near the city of Detroit. A tannery, ship builder and copper works were in this town. Its heyday was 1867 until about 1887 when it was annexed by Detroit. In the area are a Riverside Street and Riverside Park, both of which reflect the former name.

Salzburgh was platted by Dr. Daniel Fitzhugh, who named it for a salt mine and resort in Austria as there was also a salt mine in the Bay County Salzburgh. It received a post office in 1869 as "Salzburg," without the *h* at the end.

In 1877, Salzburg was described as a lumber and salt manufacturing village and was on the west bank of the Saginaw River opposite another lost town called **Portsmouth**. It had between five and six hundred people and five large sawmills, a flour mill, three salt companies and two breweries. The post office operated until 1894. It was later incorporated into Bay City.

Sand Hill was in Redford Township. It was first settled and organized about 1820, and by 1897, there were over one hundred people living there. In 1820, about a half mile east of Redford at Grand River Avenue and Burt Road, the first homes in the area were built on a sandy ridge, hence the name Sand Hill. It had a post office under that name in 1880 with a brief name change to Willmarth in 1882, but it changed back to Sand Hill just a few months later. The first school in the township was built there in 1837. A branch on the Detroit, Lansing & Northern Railroad, in 1890, Sand Hill was a stop on the Detroit United Electric Railway, and the post office was in John Parks's store next to the train station.

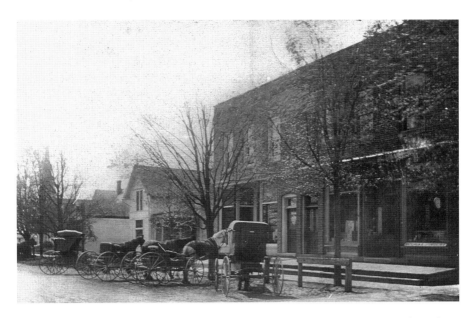

The Lenox Station joined with the nearby Beebe's Corners and Cooper Town to form the village of Richmond. Muttonville joined up later. *Courtesy of Don Harrison.*

It was absorbed into the nearby Redford Village, and most of the businesses moved there before the whole area was absorbed by vote into Detroit.

In 1906, Sand Hill, Redford, Bell Branch and Duboisville combined into one entity and, at first, used the Sand Hill name, later changing to being called Redford. Redford had its own library, fire department, post office, a Maccabees Hall used for meetings, two general stores, a shoe factory, an aviary, a glue factory and a rake factory. There were two doctors, and a large theater was built not long before 1926, when the village had an election and approved becoming annexed by Detroit. Redford also had its own cemetery.

Sherwell had a short life as a village with a post office from 1899 until 1902. It was named for Walter Sherwell, a local laundry owner, and it was a stop on the Detroit and Northern Electric Railway. It was in the area of present-day Oakman Boulevard and Grand River Avenue and was annexed by Detroit in 1916.

Springwells was one of the most established of the villages absorbed by Detroit and one almost as old. It was settled by Pierre Drouillard in 1783 and named for its abundance of springs and wells. In 1820, Father Gabriel Richards established a school called the Springwells School. Springwells growth

was enhanced when it became the next station after Detroit on the Michigan Central Railroad as it went through to Ypsilanti. The village was laid out in 1847, a few years before the 1851 construction of Fort Wayne nearby.

Ambrose Riopelle, whose family had owned several of Detroit's "ribbon farms," laid out Springwells in 1847. Ribbon farms were long, narrow tracts of land platted to let many farms take maximum advantage of the land by the water. From 1855 to 1878, Springwells had a separate post office. There was a neighboring village known as West End whose post office was combined with Springwells in 1878. Although the name still lingered on as an interurban stop, most of the town was annexed by Detroit in 1885, with the rest, which was near the present-day city of Ferndale, annexed in 1906.

But Springwells wasn't gone yet. A new Springwells post office opened as a Detroit postal substation on Springwells Avenue. The rest of Springwells Township became a new Springwells in 1921. This was beyond the town of Westman around present-day Wyoming and Tireman Streets. This incarnation lasted four years, after which, in 1925, it was absorbed by the city of Fordson, which in turn, was annexed by the city of Dearborn a few years after. Today, the neighborhood of the original Springwells is a southwest Detroit neighborhood known as Vernor-Springwells, with one of its main streets named Springwells Avenue.

St. Clair Heights was an 1880s village located in Wayne County in the vicinity of the Grosse Pointe area, at Mack and Hurlbut Streets, and had a population of about one thousand people. Said to be named for Northwest Territory governor Arthur St. Clair, it was also reputedly named for the St. Clair family who helped settle the area. In 1897, it received a post office that operated until 1918, when the village was annexed by Detroit. It was located at Jefferson and Hurlbut Streets.

Strathmoor was originally called Rose Hill and later given a post office under the name of Vandeleur circa 1890. It was a station on the DUR interurban at Grand River and Schoolcraft Roads. In 1916, the name was changed back to Strathmoor as the area became the site of real estate development boasting electric streetlights and a fire hydrant on every block. Within the village limits were a school, a bank, a Methodist church, a lumberyard and several other small businesses. It had its own newspaper, the *Strathmoor Press*. It was annexed by Detroit in 1924.

Another village annexed by the City of Warren was **Van Dyke**. Van Dyke was named after Van Dyke Road (Michigan 53), which was named for James A. Van Dyke in 1885 in Warren Township. Van Dyke was a former Detroit mayor.

This village adjoined the north end of Detroit near Van Dyke and Nine Mile Roads. Walter C. Piper platted it in 1917 and named its streets after cars, including Ford, Dodge, Packard, Cadillac, Hudson, Chalmers, Maxwell, Hupp, Paige, Continental, Essex, Lozier, Studebaker, Republic and Federal with the cross street of Automobile Boulevard. Merchant Christopher J. Bristow became its first postmaster on March 25, 1925. The post office operated until August 1, 1957, when the city was absorbed into Warren, still using the car names for street names.

Warrendale was another community that was short-lived as a separate entity and originally a real estate development. This Polish community near Greenfield and Warren Avenues was named for its main street, Warren. Warren Street was named for Revolutionary War leader General Joseph Warren. Warrendale had a weekly newspaper, the *Warrendale Courier*. Annexed by Detroit in 1925, its name survives as a neighborhood and in the name of a church and a number of businesses in the area.

The **Warsaw** community arose from the depot grounds (at one time frequented by Thomas Edison) of the Grand Trunk Railroad in 1862. It was platted by Leander Tromble and named for Warsaw, Poland. It was incorporated as a village but later absorbed by Mount Clemens. It was located in Clinton Township (now Mount Clemens) at Cass Avenue and North Rose Street, by the Grand Trunk Railroad Mount Clemens Depot, now the Michigan Transit Museum.

A notable resident was the first Polish immigrant to Michigan, Ludwik Wesolowski, who was also the first Polish notary and first Pole to be an elected public official in the United States. He was an engineer who worked on the ill-fated Clinton-Kalamazoo Canal. His daughter married a man who discovered a huge Canadian oil field. Her daughter from this union is purported to have been the richest woman in the world at that time. She became the Countess Von Zeppelin of German royalty. The Von Zeppelins were the manufacturers and developers of lighter-than-air balloons.

Wenona was the later name of Lake City before it became one of the three "lost towns" that become West Bay City and eventually Bay City. It was named for the mother in Longfellow's poem *The Song of Hiawatha*. It was platted in 1864 and officially incorporated as a village in 1877 with 2,600 people. Located on the left bank of the Saginaw River, it was a railroad terminus and had at one time the largest sawmill in Michigan. A mile and a half north of Bay Side, it was connected to Bay City by a bridge.

A post office operated for Wenona in 1865 until it became part of West Bay City in 1877.

Another village annexed to Bay City was **Banks**. It was at first named Bangor and was located on the west bank of the Saginaw River. Joseph Tromble, who bought two thousand acres in all, platted twenty-five acres into a village in 1851. It had a post office in 1864 with William Benson as the first postmaster. The community, then called Bangor for the city in Maine, had to change its name because of the existence of another Bangor in Van Buren County. The name was changed to Banks, in honor of General Nathaniel P. Banks. In 1871, Banks was incorporated as a village.

West Detroit was called Grand Junction in 1859 and was a major station for the Grand Trunk Railroad and five other rail lines. It was located a few blocks off Michigan Avenue, at that time called Chicago Road, and near Junction Street, otherwise known as Lover's Lane (denoting its evening-hours function).

In 1874, it was renamed Detroit Junction and given a post office, but in 1887, it was renamed West Detroit. Many train cars were housed in this area, which was annexed by village vote to Detroit in 1885, and many train employees built homes nearby.

West End was located near Michigan and Lonyo Avenues in 1855 and home to several brickyards because of the abundant clay in the area. Several of those brickyards stayed open until the 1980s before finally closing their doors. It was a Catholic, Polish and Ukrainian area and, at first, a stop on the Michigan Central Railroad, later on the Detroit United Railway interurban system. Some of the Catholic churches are still extant. The post office operated from 1878 to 1906, when part of it was annexed to Detroit. The rest was annexed in 1916.

Yew was originally known as **Brown's Corners**, named for early settler and postmaster John Brown, and this was the name of its first post office in 1866. The post office name was changed to Yew and was open off and on until 1902.

Named for the flowering tree, Yew was at the corner of Hubbell (then called Palmer, later Chase) and West Chicago Roads. In those days, West Chicago was a plank road to Plymouth. Yew had 150 inhabitants at the most. William Ford, father of Henry, built a small white schoolhouse called Palmer School in Yew. Yew was annexed by Detroit in 1926.

2

SUNKEN CITIES AND UNDERWATER TOWNS

Michigan, surrounded by the Great Lakes, has had a number of settlements that vanished beneath the waters of various lakes and streams.

Belvidere began in 1835, when David and James L. Conger of Cleveland, Ohio, bought land at the mouth of the Clinton River (where it enters into Lake St. Clair) and had Abel Dickerson plat a village.

In 1836, Edward R. Blackwell made a larger and more accurate plat. Lots were sold and businesses established. In 1837, the community was given a post office. Notably, the community was the home to Belvidere Bank, also known as the Bank of Lake St. Clair, which printed its own money. The president of the bank was Belvidere co-founder James Conger.

James Conger made a lot of money with "Conger's Tonic Liver Pills," which were advertised as being capable of "purifying the blood." They were said to "cure every ailment known to man."

Banks that came into being during the time when there were no federal regulations (only state regulations) were called wildcat banks. Denominations printed for the Belvidere Bank were ones, twos and threes. Two-dollar bills from the Belvidere Bank still survive even though the bank itself has been underwater for over 160 years. (There is no truth that this is where the phrases "liquid investment" or "floating a loan" came from.)

There was also a general store, a sawmill, a steamboat landing, a gristmill, a warehouse and other stores. There were carp fisheries and auto mechanics, as well as twelve to fifteen dwellings.

Unfortunately, the town had barely gotten off the ground when it started flooding due to the low water table in the area. There had been warnings from local Native Americans that the land Belvidere occupied was usually well below the water table and was therefore normally underwater, but these warnings had been ignored.

Within three years, flooding caused the whole town to disappear completely up to the second story of its two-story tavern (the upper floor was to be a hotel). By 1838, high waters so flooded the area that the community was completely abandoned. James Conger paid off all the lot buyers with his profits from Conger's Tonic Liver Pills.

Belvidere was also known as Huron Point and was located south of Metropolitan Beach by the Harley Ensign Access Site in Harrison Township in Macomb County. The entire village, including its cemetery, is now covered by Lake St. Clair. Divers continue to recover relics from the area although most traces are gone.

Another sunken city was **Rawsonville**, now mostly covered by Belleville Lake but originally a settlement on the border between Wayne and Washtenaw Counties. It was first settled by Henry Snow in 1800 and called **Snow's Landing**. Ambline Rawson came with his father in 1825, and in 1836, a village was platted by Mathew Woods, Amasah Rawson and Abraham Voorhies and called Michigan City. However, when it received a post office in 1838, the name was given as Rawsonville.

Rawsonville had sawmills, gristmills, two cooper shops, a stove factory, several dry goods and general stores, a wagon maker and three saloons. It was larger than Ypsilanti and considered as a home for the University of Michigan. When the village did not get any train service leading to it, it began to decline. So much so that in the 1880s many of its mills and businesses had closed and the townspeople began moving away. The town continued its decline until 1925, when a dam erected on the Huron River covered the remaining structures with the newly formed Belleville Lake.

The town that arose along the lake, Belleville, is considered by many to be the home of techno music due to the Belleville Three, residents of Belleville who were high school friends and started creating electronic music in their basements. Derrick May, Juan Atkins and Kevin Saunderson, the Belleville Three, started playing their brand of music in local Detroit clubs and helped create the techno music industry.

3

DEATH BY DISASTER

THE GREAT FIRES OF MICHIGAN'S THUMB AND OTHER CATASTROPHES

I magine a fire consuming an entire city block—or even an entire city like the Great Detroit Fire of 1805 did. Now imagine a fire consuming entire counties! Not once but twice!

The Thumb area of Michigan was hit by two disastrous fires ten years apart. Both fires started due to hot weather combined with dry foliage.

The fire of 1871 in the Thumb has been called variously the Port Huron Fire of 1871, the Great Fire of 1871 and the Great Michigan Fire of 1871. It was also the year of the Great Chicago Fire, which happened the same month as the Thumb fires. It had been one of the hottest and driest summers on record, and by October 1871, the Thumb area had already been plagued by many smaller fires. On October 8, the fire was fully raging throughout the Thumb and would eventually cause over two hundred fatalities and leave fifteen to eighteen thousand people homeless and suffering from fire blindness, exposure, exhaustion, lack of food and water and third-degree burns.

The Great Thumb Fire of 1881 repeated the holocaust of 1871—it had been a hot and dry summer. The lumber industry was in full force in 1871, but by 1881, it had run its course, with ecological repercussions. The lumber industry left lots of "slashings" when it left the scene. This consisted of tree branches, stumps, pine tops and other rejected tree parts. When these slashings combined with hot and dry weather in 1881, they acted as kindling for the resulting fire. It was said to be worse than the one in 1871. This time, 282 people perished in the flames, and another 15,000 to 17,000 were left homeless.

In the Great Fire of 1881, the recently organized Red Cross made the victims of the Great Fire their first assignment, with the area of White Rock (the site of the Treaty of Detroit) their headquarters as they ministered to the victims of the disaster.

Banner, or **Banner Corners**, was at the corner of Deckerville and Chevington Roads in Wheatland Township. It had a post office from 1891 until 1905. The area grew around the blacksmith shop, and the first postmaster was Charles Burget. The whole area was engulfed in the Great Fire of 1881, and most of the buildings were destroyed. Some were rebuilt, but Banner never grew much after the fire.

In Otsego County, the town named **Berryville** had the first sawmill. It was first settled in 1877, when Captain John G. Berry led a group of Civil War veterans north to start a settlement. They came to a lake, afterward called Berry Lake for the captain, and built their settlement. They soon had a sawmill, gristmill, two-story general store and school. The top floor of the general store had one of the first Masonic Lodges in Michigan, of which Captain Berry was the grandmaster.

Captain Berry was the first postmaster when Berryville was awarded a post office in 1878. In 1910, the area was plagued by a drought, and the woods around Berryville were very dry. A spark said to come from a logging railroad car started a fire that rapidly spread through the area. The residents barely had time to escape to the lake before the whole area was engulfed in flames.

And that was the end of Berryville. The fire that destroyed the town also took out all of the rest of the trees and foliage that had been the livelihood of the lumber town. All that remains of Berryville are a few foundations overgrown with new foliage.

Cato/Charleston was settled as Cato in Sanilac County in 1864. By 1872, it had grown enough to merit a post office—which was given the name of Charleston since there was already a Cato in Michigan. The village suffered during the Great Fire of 1871, especially sawmill owner Joseph Buel.

During its early years, the village had, besides the post office, a general store, blacksmith shop, brickyard and the lumber mill. All twenty-one downtown buildings were destroyed in the Great Thumb Fire of 1881. Some houses, the school, general store and a mill were all that were rebuilt as the village began its decline.

Center Harbor was a casualty of the Great Fire of 1871. It started with a sawmill built by Jeremiah Ludington in 1856 and was known as "Jerry's Hill" for him until he sold it in 1864. It was then known as Center Harbor for its location on Saginaw Bay. In 1871, it became one of the

many villages and small settlements just getting their starts that were abandoned after the fire.

Cracow in Huron County was entirely wiped out by the flames in 1871. About seventy people managed to barely save themselves by taking wet blankets and jumping into a ditch until the flames eventually rolled over them. The post office hung in there until 1874, and then that was it for the hamlet.

Elm Creek in Lapeer County was a small settlement that was burned completely in the 1871 conflagration. It managed to stagger on until 1875 when its post office closed.

Frederick was located southwest of present Mount Clemens, the county seat of Macomb County. It was originally the location of the Gnadenhutten Mission. Located at the oxbow of the Clinton River, this community also went by the name "**Casino**."

A Mr. Tremble built a sawmill here before the War of 1812. Job C. Smith built another in 1826. In 1836, Horace Stephens, of Detroit, bought land here and laid out a village that he named in honor of his brother Frederick. The fledgling settlement showed a lot of promise as the Clinton-Kalamazoo Canal was started here in 1836. The wildcat bank in the area named its bills for the canal.

Frederick was considered a major business competitor to Mount Clemens. By 1843, Frederick was the busiest port on the Clinton River. But in 1852, the mills burned to the ground, taking much of the village with it. The mills were not rebuilt and the canal project was abandoned. The village declined and was soon thought of as a ghost town.

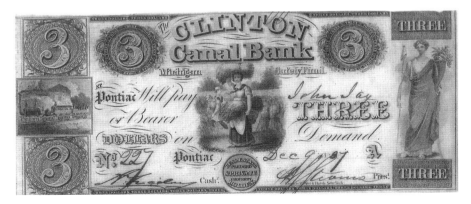

Wildcat banks of Michigan had no federal regulation and issued their own bills. Shown is a bill issued in the lost town of Frederick. The bill is named for the Clinton Canal Bank, referring to the planned Clinton-Kalamazoo Canal that was to cross the state. When railroads began to be built, the canal project was abandoned. *Courtesy of Karl Mark Pall.*

Huron City's House of Seven Gables is one of the more elaborate restorations of this logging village. *Photo by the author.*

Huron City started with a sawmill built by Thomas Luce in 1837. It was powered by the waters of Willow Creek and then was sold to a Mr. Brakeman so that it was briefly known as **Brakeman's Creek**. Huron City then became a booming lumber town and had its first post office in 1856 as Willow Creek. The mill was again sold in 1856 to Langdon Hubbard. He operated a lumber business, R.B. Hubbard & Co., there for forty years. In 1861, the town was renamed Huron City. Huron City was the first place the Huron County Board of Supervisors met, and it was in the running to be county seat.

Built on an elevated plateau overlooking Lake Huron at the mouth of Willow Creek, the Huron City site had been occupied by nomadic fishermen before its birth as a village. Nearby was the Point Aux Bauque Lighthouse. It was built in 1857 and had a U.S. lifesaving station to aid ships in distress.

Unfortunately, Huron City burned down in the Great Fire of 1871 but was rebuilt by town patriarch Langdon Hubbard. There were many trees—including beech, ash, maple, elm and basswood—in this town

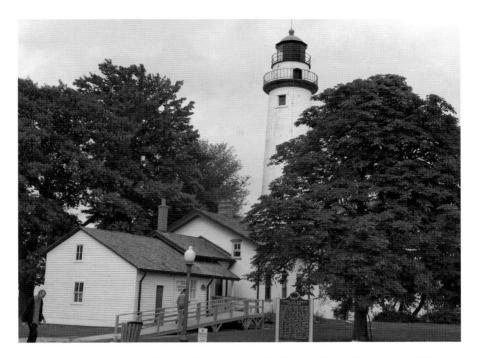

The Pointe Aux lighthouse kept its lights on even in Huron City's darkest days. *Photo by Lynn Lyon.*

prior to the fires, and afterward, Hubbard was able to build the lumber business again by manufacturing shingles, lath and flour, as well as lumber. The village had a hotel, a Methodist church, Maccabees Lodge and a cheese factory, as well as other stores. Farmers met at the North Huron Farmers' Club.

The town burned down again in the 1881 fire. Some of the buildings Hubbard rebuilt included a blacksmith shop, rooming house and mills. But unfortunately, Huron City never reached the prominence it had attained before the fires as most of the population had since moved away. The diminishing lumber industry finally drove Huron City out of business in the early 1900s as the timber had mostly been cut down. The post office finally closed in 1905. Huron City has since been resurrected as a historical ghost town, restored and maintained by the Hubbard family. It includes a general store; log cabin; lifesaving station; House of Seven Gables, named for the Hawthorne novel; hotel/boardinghouse; community inn; and church.

Meredith was known as "the most sinful city in Michigan." The first business there was a saloon, and the town was known for drinking, prostitution

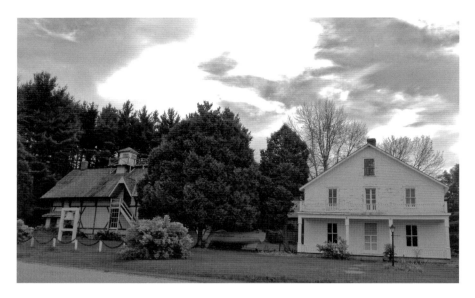

Huron City has been reconstructed and can be viewed almost any time. *Photo by the author.*

and fighting. One resident claimed he saw twenty-eight fights on the streets in just a single afternoon.

The pine lumber industry sustained Meredith with around fifty lumber camps in the area in the 1870s. The Corrigan House was the first business, a saloon and hotel, built by Thomas McClennon. It was built in 1884 and was three stories tall. Other businesses included two general stores, a meat market, two jewelry stores, a livery stable, sawmill, three restaurants and twelve saloons. The number of brothels is not officially known, but one house of ill repute was the product of Jim Carr, a well-known purveyor of illicit pastimes who opened a branch saloon in Meredith (his first tavern was in Harrison).

Meredith met its end with a series of fires in the late 1890s that destroyed the main buildings (some of the fires were said to be arson). In 1900, a huge brush fire destroyed the rest of the town.

Metz was a town in Presque Isle County settled by German immigrants in 1875. It was given a railroad station in 1895 by the Detroit & Mackinac Railroad and was given a post office the same year. Although it was at first a lumber center, when the lumber ran out, the town continued since by then it was a major shipping center. There was a boardinghouse, hotel, three general stores, a blacksmith shop, some saloons and a church located in Metz.

The town had a rowdy reputation, and the saloons were usually full. The chief entertainment was bar fights. This caused many to claim that the fire that destroyed the town on October 15, 1908 was divine retribution.

The blaze of unknown origin was first sighted at noon, and by two o'clock in the afternoon, it was out of control. A train was sent to rescue the townspeople of Metz, but disaster struck the train as it tried to escape the fire. Sixteen people were roasted to death as the train was stuck in the middle of two blazes that soon set the train cars on fire. Most of the town was burned and the townspeople left homeless. The Red Cross built a number of twelve- by fourteen-foot shacks to shelter the homeless townspeople through the winter of 1908. Some of the buildings were rebuilt, but the only surviving business was a saloon.

A fire proved to be the end for **McKinley**, which before its demise was the largest town in Oscoda County. Located on the Au Sable River about twelve miles east of Mio, it was a lumber town and a railroad stop of the Au Sable & Northwestern Railroad. Its sawmills cut over 324 million feet of lumber in 1890.

The town was originally known as **Potts** for the Albert Potts Lumber & Salt Company that started lumber operations in the area in 1884. In 1887, the company built its own narrow-gauge railroad. As Potts, it received a post office in 1888. By 1890, Potts had two general stores, a large company store, two drugstores, two hotels, a school, a church and five saloons. Probably because of the large number of saloons the town had, it also had a jail made of wood planks and covered inside and out with hardwood barrels. It had one small window that was too small for a person to fit through. It was considered "escape-proof" and probably was.

The company went bankrupt in 1890 trying to extend its railroad line too far. The interests of the Potts company were taken over by the Henry M. Loud Company, which finished the railroad and restored prosperity to the community. With the restoration came a new name. The town was renamed McKinley for William McKinley, the twenty-fifth president of the United States.

The town enjoyed prosperity until 1899, when disaster struck. The company's engine shop, railroad repair shops and roundhouse were all destroyed by a fire said to be caused by a drunken watchman who kicked over a torch at his feet. Because of the extent of the damage, the Loud company decided not to rebuild and instead moved its headquarters to Oscoda.

New River in Huron County had a good start, with two sawmills and a gristmill built there by 1856. A post office operated from 1866 until 1871, when it was devastated by the Great Fire. The post office moved to nearby Grindstone City in 1872, and New River rapidly declined until it was just a small hamlet by 1880 and a ghost town shortly thereafter.

Rock Falls was a lumbering village on Lake Huron that started in 1835. It had a post office in 1865 and was wiped out by the 1871 fire. The post office hung in there until 1875, when it closed, taking the last traces of Rock Falls with it.

White Feather was a community and railway station named for the great pigeon roost that was located on the banks of a creek. The creek was named White Feather River by Native Americans, and it flowed into the Saginaw River. The white feathers that dropped into the water were a constant presence and gave the village its name.

James Lomas built a mill on White Feather River near the spot it flowed into Saginaw Bay in 1874. About the same time, C. Ives built a shingle mill nearby. In 1874, White Feather got a post office that was open off and on until 1888, when it closed for good. The reason is that both mills were lost in a fire and not rebuilt. At that time, the population was about one hundred people.

White Rock became a historic landmark when the Treaty of Detroit between the Native American tribes and the new colonists of the United States was signed here in 1807. A large white limestone boulder marked the entrance to the area on the Lake Huron side of the middle of the Thumb.

General William Hull, later notorious for giving up Fort Detroit without a shot during the War of 1812, negotiated the basically one-sided Treaty of Detroit to free up land for the new Michigan settlers. The site, originally sacred to the Native Americans, was also the boundary for the Treaty of Detroit. The boundary line went from there to the Maumee River and was the dividing line between the white settlements and the Native American lands.

The White Rock itself was once much larger than its present appearance. The rock was partially destroyed while being used for target practice by U.S. troops during World War II.

The fishing village of White Rock began its history as a pioneer settlement on a bluff by the shore of Lake Huron. Edward Petit, the first white settler in Huron County, opened a trading post on nearby Shebeon Creek and then moved it to the area of White Rock. "White Rock City," as it was first called, was promoted and planned out in 1835–36, and it gained enough population by 1859 to warrant a U.S. Post Office, which operated until 1907.

Robert W. Irwin was the principal businessman in the town and the owner of a salt block purchased from Thomson & Co., which sold the block to Irwin after the company was burned out in the Port Huron Fire of 1871 and rebuilt. The business included three wells and, in 1884, produced 225 barrels of brine every day. Irwin's other White Rock businesses included a steam barrel-heading and stave factory and sawmill. He also had a two-story

brick business building in which he sold general merchandise. Irwin also operated the town's telegraph business.

Another general store in the village was opened by Robert Munford in 1860. He was also the postmaster and ran the post office from his store. The town had a physician, Dr. W.L. Schoales, and a brick schoolhouse. Churches included a Congregational church opened in 1879 and a Methodist church established in 1854, with the church edifice built in 1879.

The Cottage House hotel, run by Mrs. M.A. Ferguson, opened in 1859, was burned down in the Fire of 1871 but was rebuilt. The Ferguson house was so completely destroyed that the only evidence of it they could find was three clothespins.

The people of the White Rock community survived the fire of 1871 that destroyed the town by going down to Lake Huron and immersing themselves in the water until the fire was over. The smoke was so dark that nothing could be seen until it eventually dissipated.

Since the whole settlement of White Rock was burned down in the 1871 fire, it subsequently, despite its early promise, did not grow beyond a small community. That being said, the village continued after the 1871 fire and had a few more good years as a village before becoming a mere shadow of its former self by the 1920s. The closest train stop was at Adam's Corners, also known as Ruth.

There was a town that survived the fires only to be destroyed by a tornado. It was named **Amadore** and was one of the first settlements in Sanilac County. It began with a log cabin built at the intersection of two Native American trails around 1800; it was a stagecoach stop in its earlier days. Later on, the railroad came through the area, a result of a fight between the towns of Lexington and Croswell to bring it through their towns, and the village grew. The original route plan was to bypass Croswell and, therefore, also Amadore, but when Croswell got the route changed, the railroad began going through Amadore. Amadore was thereafter a stop on the Port Huron and Northwestern Railroad and, beginning in 1879, the Pere Marquette Railroad. The railroad yards were quite extensive, consisting of a stockyard, coal sheds, two hay sheds, an elevator and the depot.

The hub of town was at Galbraith Line and Wildcat Road, in Worth Township. The hotel was the Reynolds Hotel, named for Civil War veteran Arnold Reynolds (who lost a leg in the war) and his son, Joshua. There were also two blacksmith shops, a school, two churches, a small shoe factory, a furniture shop, a jewelry store, a large cider mill, a barrel stave shop, the post office and even a community building.

It was also called **Galbraith's Corners** because its first postmaster was county surveyor, Jefferson W. Galbraith. John Galbraith was the town physician.

A mailman on Wildcat Road in Worth Township about 1910 is making deliveries. In the back is an Octagon House built in 1869 by retired seaman and Scotsman George Smith. The house is one of the few to survive the Amadore cyclone. *Courtesy of the Sanilac County Historic Village and Museum.*

Pioneer settler Amadore Fuller's first name eventually became the name the village was known by. The village post office operated from 1868 until 1934.

The town's demise came about due to a cyclone in 1897 that swept through and destroyed the town in just minutes. Almost every single building was damaged beyond repair. The only trace of the Presbyterian church was two brass fittings from the lights. The rest of the church was never found. One house in the community was picked up by the force of the wind and left in a tree on the east side of town.

The town of Amadore never recovered from the cyclone. Most of the townspeople didn't rebuild. The school was one of the few buildings that was rebuilt but was rarely used afterward. One of the few buildings that survived was the Octagon House of Scotsman George Smith, a retired seaman who built the house in 1869.

Worth Township in Sanilac County was also where **Stevens Landing**, also known as **Birch Beach**, was located. There was a school, a hotel, a church, some stores, several sawmills and a blacksmith shop.

4
SAWDUST CITIES AND
MINING TOWNS

S awdust City" was the term used to refer to the many lumber towns of Michigan. Towns would spring up, built by the lumber companies to serve the many lumberjacks the lumber trade employed. And then, as the lumber ran out, the town would fade away.

The first permanent settlement in Presque Isle County was **Crawford** (also known as **Crawfords Quarry**) on Lake Huron. Settled by the Crawford family in 1860, it was given a post office with Francis Crawford as the postmaster in 1864.

The Crawfords dominated the local economy. They built a dock and shipped lumber, cedar posts and other wood products derived from the thousands of acres of pine and hardwood forest on their properties. They also shipped limestone from a quarry on their land.

By 1870, a new town nearby had been laid out by some surveyors. It was named Rogers (later Rogers City) for the U.S. commissioner of surveying William E. Rogers. It soon became an economic rival to Crawford, and when it came time to name a county seat for Presque Isle County, both Rogers and Crawford claimed the honor. Each side built a courthouse, and for a while, the county had dueling governments. But in 1875, Rogers was named the sole county seat, and the courthouse at Crawford soon stood empty. The contractor never did get paid for building it. The Crawford post office closed in 1900. In 1910, the town had a brief resurgence when the Michigan Limestone and Chemical Company bought the property for its mines and renamed it "Calcite."

But the revival was short-lived. The area that was Crawford is now part of Rogers City.

"The Lost City of **Damon**" was how Owosso-born author James Oliver Curwood described northwestern Ogemaw County's town of Damon in his 1927 novel, *Green Timber*. Damon had seen its heyday starting in 1875, when George Damon of the Cutting and Damon lumbering operation moved north from Beaver Lake and established the town of Damon on the old State Road from West Branch to Luzerne. This was on the Michigan Central Railroad line.

The first structure was a large log building that was used for the lumber business. The state road led up through Damon and on north to the lumber camps. In the center of Damon was a public square and turnaround for the stagecoach that came through. Residences were erected along a side street. A hotel was built with an implement store across from it. A gristmill was built, and a spring provided pure water. A colonist who falsely claimed the land on which the spring was his (and tried to charge for the water) was dealt with in "frontier fashion," according to the Curwood book.

There were a couple of other businesses, including the Hendrie general store, which had operated for many years. An ex-convict, John Bacon, owned another general store. Whiskey was his biggest seller, and his place also served as the local blind pig. Off the town square was a large structure used variously as a school, town hall, church and all-around general community meeting place. The building was used for weddings, dances and amateur theater productions, and when the circuit judge came through, it became a courthouse.

The lumber operation was sold to the Davison brothers from Lapeer. The Davisons built a large log general store and a seventeen-room, two-story hotel in Damon. They also erected a livery stable for twenty-four horses.

In 1893, the Davison brothers sold the town of Damon to A.J. Warner for $350. He operated the store and hotel until 1906, when he sold out to a small lumbering company that cut down the remaining lumber in the area. The post office closed in 1911. By 1915, the town site had been abandoned, and the remaining buildings had been torn down or moved away.

In the 1930s, the Curwood book came out, and Damon, as a lost city, gained fame and tourists. In the story, the protagonist hides out in what is, by then, the ghost town of Damon. The area became a tourist stop when the book became popular. Small signs were erected in the former town area showing the location of the buildings. The signs had small sketches of what the buildings looked like. Today, those signs are long gone, and there is nothing left in the former fishing village and lumber town of Damon.

Glencoe was a Bay County sawdust city that formed around the sawmill of George Campbell in 1873. It was located on the north branch of the Kawkawlin River. George Campbell was also the postmaster from 1876 to 1878. This lumber town had a railroad spur leading to it.

Grindstone City in Huron County was a village that failed in the same way as the lumber towns. Grindstone City's prosperity was due to its grindstone business, and when it failed, the town returned to its beginnings as a fishing village. Grindstones were used to grind and sharpen tools. Sandstone was needed to make grindstones and was in abundance in the area. Besides grindstones, the business produced whetstones, axe bits and scythe stones. Grindstones from Grindstone City were shipped all over the world due to the industrial boom at this time.

Instrumental to the rise of the fledgling industry was the first man to put his nose to the grindstone. He realized that the peculiar bluestone sandstone of the area was perfect for making the grindstones that the world needed.

Grindstones on the beach. The company that made the grindstones abandoned much of its stock when grindstones became obsolete. *Courtesy of Don Harrison.*

The farmers of America needed to sharpen their tools every morning before starting their work. This grindstone captain of industry was Captain Aaron G. Peer, who sailed into the area in 1845 and found a small but thriving grindstone quarry business operated by two men—Pease and Smith. Purchasing the business, Captain Peer expanded it by starting a grindstone mill.

Soon another grindstone quarry in the settlement opened, and the settlement needed a name. At first the settlers leaned toward "Stonington," but they eventually decided on Grindstone City. Although the Great Fire of 1871 leveled the town, mostly consisting of wooden frame buildings, by 1872, enough rebuilding had occurred to get a post office with James Green as postmaster. It also became a stop on the Pere Marquette Railroad.

Besides the axe bits, whetstones and scythe stones, a lot of stone was cut and sold as building blocks. Paving stones sent to Detroit were used to pave Jefferson and Woodward Avenues.

Grindstone City had four fishing operations in the vicinity in its heyday, as well as three hotels—including the Grindstone City Hotel and the Huron Hotel. There was a gristmill, as well as attorneys, real estate companies, a Methodist and Baptist church, a dentist, a school and a wagon and carriage factory. The town had wooden hitching posts but had to switch to metal because the horses started eating the wood.

In this formerly busy company town, only a general store is left. *Photo by the author.*

Grindstone City had a canning factory and the "Red Boarding House," in which a singing school maintained residence. There were grocery stores, a meat market and a row of houses called the "Red Row" built by the Stone Company for its workers. There were, of course, blacksmiths and also a box factory.

In the 1890s, the development of silicon carbides, also known as carborundum, put an end to the grindstone industry. Carborundum was a more easily produced abrasive that could be used to sharpen tools. The grindstone factory closed, the town declined and the post office finally closed in 1962, causing Grindstone City to revert back to the sleepy fishing village it was before the grindstone industry came and went.

Kawkawlin was a sawdust city in Monitor Township in Bay County and was settled by lumberjacks. In 1844, the second sawmill in the county was erected here. By 1855, the village had both a water-powered mill and a steam-powered one. Located near the nexus of an old Indian trail, the town was organized and received a post office in 1868.

Kawkawlin was once said to have "two mills, five cottages, two hog huts, several Indian wigwams, and 100 million mosquitos" by a disgruntled settler. Kawkawlin was also the site of other businesses, including a dynamite factory. One settler, "Uncle" Harvey Williams, was a blacksmith, manufacturer of agricultural implements, lumberman, fisherman, fur trapper and builder of engines. When the lumber was gone, Kawkawlin faded away.

Selkirk was a lost town that was built on the site of another lost town, an Ottawa Native American village. It was a lumber town that began with cutting the Norway pine and white pine trees. When that lumber ran out, the hardwoods were cut. Selkirk got its start in 1870, when a plank road, State Road M-55, was completed to run from Tawas to Manistee. It was made of planks and logs covered with gravel and dirt. A hotel was built in 1870, and a general store followed. In 1887, a post office opened. By 1900, there was a blacksmith, a sawmill, a school, some churches and several hundred people. The post office hung in there until 1955, but the town greatly declined once the lumber was gone.

In the area along the river in Selkirk were three circular and one rectangular Native American earthworks marking an earlier Ottawa Native American village. These have been dated to AD 1300.

In Otsego County near the top of the Lower Peninsula, **Waters** was a lumber town on the Michigan Central Railroad route. It began in 1873 with a sawmill built by the Wright-Wells Lumber Company on the north end of

The famous Glass Bottle Fence helped the village of Waters keep from dying out a little longer. *Author's collection.*

Bradford Lake. The lumber company also owned a large general store and a hotel. In 1876, the post office opened, and a railroad station was built. Although the official name of the post office was Lake Bradford, in 1885, it was changed to Waters, for the many lakes in the area.

By 1888, the lumber was running out, and the town was failing. However, it had a rebirth in 1891, when the Henry Stephens lumber company relocated in Waters after having been in St. Helens in Roscommon County. After the lumber was depleted completely, the town again went into decline.

In 1912, Henry Stephens's son, Henry Jr., built a large home in Waters and constructed a large bottle fence, using all kinds of bottles. It was 110 feet long and 5 feet high, and it had a wrought-iron gate in the middle. Although he called it a monument to the lumberjacks, it was Henry Stephens's name that graced the fence. The fence was featured in the famous comic strip *Ripley's Believe It or Not.*

To construct the fence, Henry Jr. paid neighborhood children a penny per bottle to collect the supplies for his fence. It was rumored that many of the children would steal the bottles at night and sell them back to Stephens in the morning.

In 1970, the glass bottle fence was moved to the back of the lot when the highway expanded.

5

GREAT BATTLES FOR COUNTY SEATS

There was a lot of clamoring among villages in the early days to be named the county seat. This was mostly due to the growth, added commerce and increased prosperity that being named county seat brought. Some of the settlements that failed in their quest to become the county seat also failed entirely shortly thereafter and became ghost towns.

In St. Clair County, the original county seat in 1820 was St. Clair, later renamed **Palmer** for postmaster Thomas Palmer and then changed back to St. Clair in 1846. Palmer was its name when the first county courthouse was built there in 1827. Because it took Palmer seven years to build a courthouse, the nearby city of **Newport** (now Marine City) petitioned to have the county seat moved there and even raised money to be used for a courthouse. After a while, the furor to change the county seat to Newport died down; however, up the river, Port Huron was growing and, in 1842, began making noises about becoming the county seat. After a number of years, in 1866, Port Huron won a referendum to change the seat, but St. Clair disavowed it, taking the matter to the state supreme court. The court, citing election irregularities, ruled in St. Clair's favor.

The citizens of Port Huron felt they would never get the seat changed as long as it was in St. Clair. So they changed their focus to getting the county seat out of St. Clair and, in 1869, were successful in having it changed to **Smith's Creek**, a small burg in the middle of the county that was a stop on the Grand Trunk Railroad. It was considered a backwater town, and it doesn't appear that much county business was conducted there as St. Clair

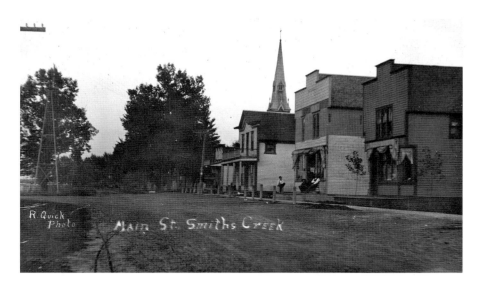

Smith's Creek, around the time when it was the county seat of St. Clair County. *Courtesy of Don Harrison.*

Modern-day Smith's Creek has a few businesses but not very many. The church whose steeple you can see in the top image is shown in the bottom photograph rebuilt with a smaller steeple. *Photo by the author.*

refused to transfer any of the county records. Smiths Creek had established a post office in 1861. The town was named for local landowner Elisha Smith. Smith's Creek—or **Smith's Creek Station**, as it was also known—has one

other claim to fame. It was where Thomas Edison was physically thrown off a train because a chemistry lab he had built in the back of the train caused a fire. That Smith's Creek depot is now in Greenfield Village.

Finally, in 1871, Port Huron won a referendum for the county seat. It eventually managed to pry the county records away from St. Clair, although it took another Michigan State Supreme Court ruling to do it.

At least there wasn't any arson recorded, as was highly suspected in Lapeer County. In 1831, Alvin Hart and his family settled in what became the county seat, **Lapeer**. Alvin Hart became the first sheriff of Lapeer County in 1832 and was later a state representative. Other families joined them in what was, at first, a hardscrabble existence.

Settlers would plant hay and graze cattle in an area that became known as Squabble Meadow. Farmers would cut hay and leave it to dry, and it would be claimed and taken by others. This led to many fights, and finally, a hard-fought hay-cutting contest was undertaken by two stalwart men remembered only by their surnames, McClellan and Smith. Tragically, both men died within a few days of the contest due to heat exhaustion and overexertion.

In 1832, the Lapeer settlement was named the county seat of Lapeer County. A rivalry between two of the early settler families, the Harts and the Whites, intensified over the issue of which side of town the Lapeer County courthouse would be on. The settlement of Lapeer had been restricted, up to this point, to two small areas divided by a tamarack swamp, with the Hart families on the northeast corner of what is now the city and the Whites on the southwest corner. One of these hamlets was actually platted to be a separate village known as **Whitesville** and had a post office by this name from 1834 to 1836, but it became known, along with the Hart part of town, as the Lapeer County Site around 1836.

Residents of both sides of Lapeer wanted the courthouse in their sections. The Whites, whose sympathies lay with the more conservative Whig Party, built a courthouse in the Whitesville portion, but it burned down—incendiary materials were suspected to have been used. While the Whites were building another courthouse, the Harts, who were Democrats, had also built a courthouse in their part of Lapeer. For a while, both courthouses were used and were called the Upper Town Court House and the Lower Town Court House. Eventually, the Hart section's new courthouse was chosen by the county officials as the court's permanent location, and the White section's building became the Lapeer Academy, the first school in the area.

Tuscola County had a provision that the village of **Vassar** would be the county seat until otherwise designated by the board of supervisors or

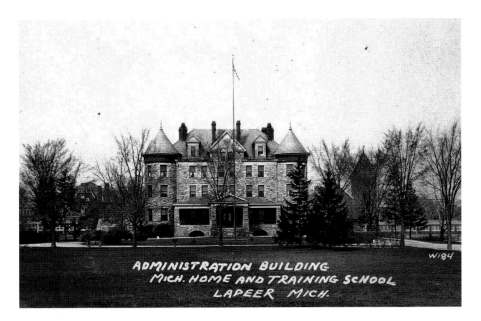

In Lapeer, the upper and lower parts of the town fought to be the section with the courthouse. One became the courthouse, the other a school. *Courtesy of Don Harrison.*

1860, whichever came first. Well, 1860 came first and the board was legally obligated to designate a permanent county seat. Many wanted to keep Vassar, and many wanted the more centrally located Centerville (now Caro). Very briefly, the board designated **Moonshine** as the county seat, and the town promptly began to build a log courthouse. The roof hadn't yet been put on when the town received word that the county seat designation had been rescinded. Moonshine as a settlement thereafter disappeared. Also, the other contenders, **Heartts** and **Ketchum Plat**, appear to have disappeared completely after making rejected bids to be the county seat in 1860.

Huron County and Sanilac County had similar stories. In Huron County, the battle was between the original seat of Sand Beach (now Harbor Beach) and Bad Axe, though the seat did briefly occupy Port Austin as well. Bad Axe eventually won in a close election.

In Sanilac County, the fight was between Lexington, the original seat, and Sandusky, the eventual winner. The schism was great enough that, at one time, thirteen members of the board of supervisors would meet in Sandusky and ten in Lexington. Sandusky, after a few elections, eventually won the prize.

At least most of those cities were around longer than **Pere Cheney**, which disappeared around 1912 after reigning as the county seat of

Crawford County. Pere Cheney started in 1874 with the opening of the sawmill of G.M. Cheney, known as "Papa." A lumbering operation was begun as well, and Pere Cheney was granted a post office. Pere Cheney was the first settlement in Crawford County, and when the county was organized in 1879, it became the county seat. It was a stop on the Jackson, Lansing and Saginaw Railroad.

Grayling nearby was centrally located and soon grew to have more population. The citizens felt that their town should therefore become the county seat, and they convinced the county supervisors to make the change. The Pere Cheney contingent put up a fight but lost to Grayling, even though Pere Cheney made a good argument that the Grayling people padded the city's population figures with itinerant lumberjacks. A delegation came on the train from Grayling and seized the county records.

Although losing the county seat was a setback for Pere Cheney, it wasn't the end yet because by 1881, the town had a large general store, a hotel, three sawmills, a school and a railroad depot. But by 1890, the lumber began to run out. Since the sandy soil wasn't good for farming, families started to move away. In 1911, the post office closed. By 1918, only about eighteen people remained in the village. The village was also plagued by disease—diphtheria sent many of the town inhabitants to the Pere Cheney Cemetery, which was finally all that was left of Pere Cheney. Today, the Pere Cheney Cemetery has had most of its headstones vandalized and is known as one of the most haunted places in Michigan. The way to the location of Pere Cheney is down a worn country road.

LOST TOWNS THAT WERE RELIGIOUS COLONIES

In the annals of Michigan settlement there have been a few settlements established on religious beliefs. The Thumb area of Michigan is still the home of many Amish groups that still use horse and buggy for transportation.

The town of **Ora Labora** was in some ways similar to other religious colonies that struck out on their own—Jamestown and Plymouth for example. But unlike the many that ended badly, such as Jonestown, Waco and Roanoke Island, Ora Labora had a different type of ending—the town went bankrupt.

Ora Labora (originally Ora et Labora, Latin for "pray and work") was a planned religious community that started in 1860 with the purchase of three thousand "swampy" acres in Huron County on Wild Fowl Bay for $1.25 an acre.

The story of this religious colony began in Pennsylvania when German immigrants settled in Economy, near Pittsburgh. In search of religious freedom, the colonists banded together, and each pledged to share all his or her property with the colony. In a show of unity, the members all dressed alike. The colony was named Harmony and grew to be so prosperous that it had to spread out in order to produce more food for its growing population. But the settlers in the lands surrounding the colony of Harmony had labored hard just clearing the land and did not wish to sell. So to feed its people, the colony was forced to form other colonies away from its original location.

In the meantime, in 1848, the state of Michigan published a pamphlet in German and English extolling the virtues of the area, hoping to entice

more hardworking German immigrants to move to Michigan. (Michigan was trying to overcome the negative reputation it had of being a swampy, bug-infested wasteland.) A German immigrant named Emil Baur took the bait. He had moved from Germany to Michigan and become a missionary for the Methodist Christian German Agricultural and Benevolent Society.

The nineteenth century was a time when utopian communities abounded. With the religious and political freedoms of the era came a feeling that the perfect Christian community could be built. Most such colonies were of a socialistic political philosophy, along with a fervent religious foundation with regulated times for prayer, religious study, labor, etc.

The German Methodist movement was the impetus, with the New Bethel colony of Massachusetts and Harmony, Pennsylvania, as blueprints for the colony that Baur began to plan. He decided to continue the work started by the Harmony colony and form an extension of it, with the goal of people praying and working together and preserving the German culture and language in the New World. Education of colonists and care of the elderly and orphans was also a consideration. Baur wrote that, at Ora Labora, "the farmer does not have to pay profit to the storekeeper, nor the shoemaker to the canner, nor the smithy to the farmer or the farmer to the smithy."

The settlement wrote a constitution and sold shares in a joint-stock company, which bound the members together for ten years. The total number of shares was four thousand, and the official name was decided to be the "Christian German Agricultural and Benevolent Society of Ora Labora." Each family was to pay a five-dollar admission fee, and the stock would be sold at twenty-five dollars a share—each family would contribute what they could and be issued the stock certificates.

The constitution also ascribed to the pray and work philosophy with card playing, theatrical productions and dancing prohibited. However, the growing of hops and the brewing of beer was allowed due to concern about unsafe water sources, which could cause fever and disease. (Also, the beer helped preserve the German culture!) In all, 288 people signed the constitution and joined the colony in 1860.

A site was selected in 1862 in Huron County on the Saginaw Bay on the old Sand Ridge Indian Trail at a location between Old Bay Port and Mud Creek. The Sand Ridge Indian Trail was also the road for the stagecoach that ran along the upper Thumb during the 1800s. In 1862, the town had been platted, and an ad was placed in newspapers to look for colonists. Several small log buildings were built at first, and soon a large boardinghouse was built for single men and families waiting for their cabins to be built. Each

family got a log cabin, and soon nine were built, with more to follow. Even though the year was 1862 and the Civil War was building up, the colony got off to a good start. (The Civil War eventually helped lead to the failure of the colony as more and more able-bodied young men were drafted to help in the conflict.)

Monday through Saturday, every able body was expected to work. There were worship services on Tuesday, Thursday and Friday, with prayer meetings on Wednesday and Sunday nights. Several other events occurred on Sundays, as well.

In 1863, twenty-three new families joined, and a school was erected. The colony school had forty-two children for the first classes. By plan, the school taught literary, scientific and religious information. Classes were in session for three hours in the morning and three hours in the afternoon. The building was also used for a church.

A village was laid out with wide, fruit tree–lined streets, a German custom. A general store was erected for the use of the colonists. There they could purchase flour and other necessities using the script issued by the colony. There was a post office building where mail would come by stagecoach, a tannery, a fishery, several workshops and a bakery. One of the perks of the colony was "daily bread," as bakers would make a loaf a day for each colony family.

A blacksmith joined the colony, as well as a shoemaker. Most others worked in the fields or digging ditches to battle the encroaching swamplands. When one of the colonists' five-year-old daughters died, a cemetery was platted.

Each colonist was to receive two cows, two pigs, two chickens and a half-acre plot for his or her personal use. There were a few horses in the town—not a lot, but enough to keep it from being a "one-horse town."

For the benefit of the colony, members were expected to plant fruit trees and grapevines and to work every day except Saturday and Sunday. On Saturday, each colonist worked for himself.

Everyone was required to get up at 5:00 a.m. (they were awakened by the blowing of a horn) and attend a church service of devotions a half hour later. Breakfast was at 6:00 a.m., and then the working day went from 6:30 a.m. to noon and from 1:00 to 6:00 p.m. At 9:00 p.m., there were religious services. There were restrictions on leaving the colony without permission.

The town streets were laid out and named, most after trees: Bay, Cedar, Elm, Sycamore and Cherry. Cross streets were named numerically: First, Second, Third, etc. Many of the streets were named for trees because Ora Labora was another of Michigan's six hundred "sawdust cities," or lumber camps—although a lot of farming was attempted. The specialty of Ora

Labora was telegraph poles. In mid-1863, there was a "long dock"—220 feet—built into Saginaw Bay, with railroad tracks on it. This made it easier to load the lumber onto the boats that carried it to Bay City or Saginaw to be cut. Colony founder Emil Baur was against the long dock's construction because he thought it would be washed away. Unfortunately, he was right. The dock was swept away the next year.

By 1865, with many of the men off fighting the Civil War, the colony was suffering financial problems. It sold 740 acres of its land and took other steps to decrease costs, including lowering wages paid to workers. Colonists began to leave.

The colony also lost many members due to the proliferation of mosquitoes, which spread malaria, which the colonists called "ague" and was characterized by chills and fevers so high the victim hallucinated. Quinine was useful to treat the disease, but it was rare and expensive. Attempts to duplicate the medicinal qualities of quinine resulted in many concoctions that some said were worse than the affliction itself.

To make matters worse, the colonists blamed the fog, not the mosquitoes, for their sickness. In attempting to make their houses airtight against the fog (using thick shutters on the windows and heavy insulation), they lacked ventilation and were excessively hot in the summertime. Many colonists blamed the water and would drink only beer, which they considered safer due to the brewing process. This resulted in many colonists being in a constant state of inebriation, which caused its own difficulties.

As colonists left, other families would move up into their "nicer" cabins. A salt business in 1865 was successful for a while and provided enough income to stave off bankruptcy for the colony for another year, but by 1866, the colony was again in serious decline. The colony fended off rumors that it was closing and would lose its post office, but the damage was done. The rumors became true, and the post office did close. By January 1867, there were just ten families left. The colony assets were divided among them and the villagers slowly vacated. Many, in retrospect, felt that most of the colonists didn't have "the knowledge and hardihood to be pioneer backwoodsmen."

In 1871, during the Great Fire, a group of Chippewa took refuge in the mostly empty cabins that were there. In 1872, the post office, which had been called "German Colony, Ora Labora, P.O. Huron Co., Mich.," was moved to Bay Port.

Many of the remaining buildings were moved. The school/church ended up in Pigeon and served as a church. All that remains of the location today are the Sand Ridge Trail and a few roads and ditches.

Another religious colony was **Gnadenhutten**, sometimes called **Moravian Village**, which was a Moravian Indian mission founded by Reverend David Zeisberger in 1782 in Macomb County. It relocated in 1786 because of the increasing hostility of the Chippewa. The name means "tents of grace." It is called New Gnadenhutten in Moravian history to distinguish it from other places in which the sect had used the same name. Its site is marked by a small monument on Moravian Drive, just west of Mount Clemens. The village of Frederick was later founded in the same area.

Frankenlust was where the Reverend Ferdinand Sievers established a colony of Bavarian immigrants in 1848. It was in the area formerly known as Kochville Township when it was part of Saginaw County, but it was renamed Frankenlust Township when Kochville was annexed to Bay County. The settlement of Frankenlust was located at the intersection of Westside Saginaw, Three Mile and Delta Roads.

Frankenlust was named for the district in Bavaria that Reverend Sievers was from, Franconia, and the German word for pleasure, *lust*. Reverend Sievers led the group from Bavaria, Germany, to the Frankenlust colony in 1847. He purchased 645.7 acres of former Native American reservation from the U.S. Land Office in northern Saginaw County in 1848 and moved the colony, supplemented by more arrivals from Bavaria. In Dierker's Barn, the colony formed the St. Paul Evangelical Lutheran Church on June 22, 1848, with Reverend Sievers as the pastor. In 1857, a frame church was built to replace the log cabin, and in 1905 a brick structure was built.

The Frankenlust post office was in existence from 1850 until 1892. Although the community died out with the post office, the church still survives and the township it is in is still called Frankenlust.

Not exactly a designed religion-based society, **Three Churches** in Bay County was nevertheless a very religious community with a church on practically every corner. It was on Old Beaver Road where the road crossed the Indian trail later known as Fraser Road in Bay County. Churches of three different denominations were established there: St. Bartholomew Evangelical Lutheran Church, Sacred Heart Catholic Church and First Baptist Church. Not far from this "holy area" was the Christian Apostolate Church and later also the Fraser Road Church of God.

The congregation of St. Bartholomew was established by German Lutherans in 1888. At first, only German was spoken in the sermons, but English was added gradually in the 1920s. This church is still extant in an edifice built in 1949.

Sacred Heart Catholic Church was started in 1891 by French and Irish settlers. The first church was built of wood and burned down in 1899. It was replaced by a new church in 1911. In 1971, another new church was built.

The First Baptist Church was built on the northwest corner of the crossroads in 1892. After a number of years, the church members all moved on, and the building was transferred to St. Bartholomew Lutheran Church to be used as a school.

Immigrants from the Alsace-Lorraine section of France and Germany built the Christian Apostolate Church in 1906–07. They spoke German, French and, presumably later, English. The congregation had originally settled in Illinois and Iowa before settling in Bay County, Michigan.

The Fraser Church of God used the old building of the St. Bartholomew Lutherans when the Lutherans built a new church. They moved the building down Fraser Road a half mile, next to the Christian Apostolate Church, in 1950.

TOWNS DESTINED TO FAIL

PODUNK AND POVERTY NOOK

I n the case of some villages, it seems like they just weren't trying to make it. Naming a town where you want other people to move something like "Whore's Corners," which was the name of a place in the Upper Peninsula, just puts the odds against it to develop into a long-lasting community. Other communities located in the Thumb were also not adept at choosing names.

Angle had a post office in 1878–79, hardly enough time to also be known as **Packs Dam**. Perhaps neither Sanilac County settlement survived due to the odd choice of names.

Bacon was a former name for the Wayne County's Glenwood post office. It seems like it would have lasted longer since everyone loves bacon.

Bark Shanty Pointe was better known, perhaps for obvious reasons, as Port Sanilac in Sanilac County. This was probably because its citizens didn't want their town to be named for a small bark shanty built around 1840 on the beach. The post office was first called Port Sanilac in 1854, and the town thrived after the name change—it even possessed one of the leading musical groups of the county, the Sanilac Coronet Band, organized by A.B. Caswell.

Burden, also known as **Berden** and **Jerusalem**, was a few miles from Sandusky at the corner of Snover and Davis Roads in Custer Township in Sanilac County. Although it apparently went by a few names, its post office only lasted from 1897 until 1904 and was located in the general store of James Mahon.

Cash was located on Cash Road and Applegate Road in Watertown Township, Sanilac County, and was settled by Edward Cash in 1851. David

Fowles built a shingle mill and a sawmill in 1882, and the next year, a general store was opened by William Tomelson. In the general store, the post office was established in 1883. In 1877, a Methodist church joined the community, and a Baptist church came in 1878. Another sawmill was added in 1882. A store that sold "good dishes" and "better furniture" was patronized from far and wide. Cash's post office closed in 1905 as credit became more popular.

Duff was around long before the beer of the same name in the long-running Simpsons show. It had its start in 1885 as the official home of the Second Presbyterians. It was at Duff Creek, at the corner of Wood and French Line Roads in Sanilac County.

Hen Town was a German settlement at Huronview and Washington Roads in Sanilac Township of Sanilac County. Besides poultry, there was the Union School and St. John's Lutheran Church, which also had a school and a cemetery in the early 1900s.

Hicks had a short life with a post office operating from 1893 until 1895. It was on the corner of Brown and Hall Roads in Sanilac Township, Sanilac County. It was also known as Buel Center, probably preferred as a name since many of the residents were quite sophisticated.

Kaiserville was conceived by the lumber firm of Van Etten, Kaiser & Co., which built a railroad from its mill in Pinconning to a new one in Kaiserville. Unfortunately, while Pinconning flourished, Kaiserville did not. Maybe it's better not to name your town after a leader of a country at war with the country you live in.

Mullet Lake and **Corpse Pond** were both Sanilac County areas that were not guaranteed to have the travel bureaus printing up brochures, except for maybe around Halloween.

Podunk is a name used to indicate a small place of little or no significance. This wouldn't be the name you would want to give what you hope will be a future metropolis. But Michigan had a town named Podunk, said to be named for an early settler. It was located in the northwestern corner of Gladwin County in Sage Township. This lost town was at the crossroads of Ziemer and Sage Roads. The remains of this one-time lumber village include a long-abandoned church, the Podunk Free Methodist Church, on one corner and the long-abandoned Podunk School on another corner.

Podunk was first settled in the 1860s. Podunk's school was built in 1904 to replace an older version. In 1934, the now abandoned church was constructed. There used to be a dance hall that was the center of Podunk's entertainment district. It was a two-story frame building and had a lunch counter on the second floor. It cost a nickel for coffee and ten cents for a hamburger.

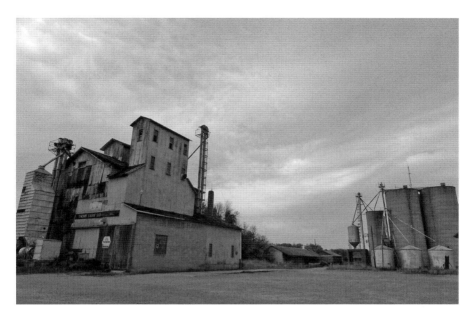

The town of Hemet was named for a history writer. Before that, it was called Poverty Nook. The name change unfortunately didn't help the town prosper. *Photo by the author.*

The nearest store was three miles away in either **Skeels** or **Oberlin**, two more lost towns. The dance hall was torn down in 1939. The last bit of life in Podunk died when the school closed in 1955.

Poverty Nook was called by this sobriquet for the row of wooden shacks that stood within the village limits. The townsfolk decided that the future of their town would be better served with a name change. The name they chose was **Hemans**, for Michigan historian Lawton T. Hemans, a move most Michigan historians, including this one, agree with whole-heartedly.

Tar Paper Corner was an oddly named Bay County crossroads village at Beaver and Eight Mile Roads. It was also called **Lixey's Corner**. Around 1900, Streval's Hall, a recreation and dance hall, was located here.

WHEN THE POST OFFICE CLOSES, THERE GOES THE NEIGHBORHOOD

In the early 1800s, if an area met the requirements for a post office, it would be granted one if a postmaster stepped up and posted a bond. It was prestigious to be a postmaster and a boon to the growth of an area to be granted a post office. Postmasters were exempt from military service although they were required to occasionally help with road building.

The postmasters would be sworn in with this oath:

> *I, _____, do swear/affirm that I will faithfully perform all the duties required of me, and abstain from everything forbidden by the laws in relation to the establishment of the Post Office and post roads within the United States. I do solemnly swear/affirm that I will support the Constitution of the United States.*

Many times, the first business in town, looking to expand the town and its customer base, would petition to have the post office. Villages and their post offices were often named for the postmaster; however, often the post office name requested was not available, and the Postal Service would assign a different name.

Post offices were located in general stores, hotels, grocery stores and other businesses. In many cases, when the post office went out of business, so did the town.

Rural Free Delivery, an act passed by the U.S. Congress in 1896, spelled doom for many of the rural post offices, and when they closed, many of the

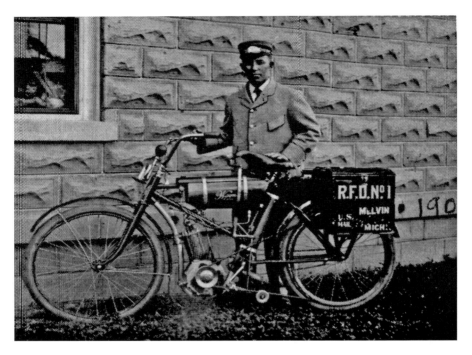

Many communities, such as Melvin, counted on their post offices and mail service to maintain their town identity. *Courtesy of the Sanilac County Historic Village and Museum.*

small towns did, too. By 1917, the whole area of eastern Michigan had been converted to Rural Free Delivery at the expense of many rural post offices.

Abbottsford in St. Clair County goes back to 1816, when a sawmill was built on Mill Creek by Ignace Moross. The name for the town came from James Abbott, who first bought the Moross sawmill and then purchased the gristmill of Judge Zephaniah W. Bruce. Jabin Cronk was the postmaster of the post office that operated from 1892 until 1942.

Blaine was a community in St. Clair County's Grant Township. The settlement started in 1828 when Thomas S. Knapp built a sawmill, and it was first called **Grant Center** for President Ulysses S. Grant. Because there was already a post office with that name, the community changed the name to Blaine to honor U.S. senator James Blaine (and presidential candidate) in 1879. The post office didn't close until 1960. Maybe they should have waited to see who won the election.

The settlement of **Bruce** had a rural post office in 1835. The town had been surveyed in 1817 by Joseph Wampler, and the first land sale was to David Hill in 1821. When the town was organized in 1832, it was decided it

would be named Bruce for the Scottish hero Robert Bruce. The post office closed in 1853, but the name lives on, as the township is still called Bruce.

Cady, or **Cady's Corners**, was first settled by Chauncey G. Cady (1803–1893) in 1833, and he held the offices of township supervisor (1833) and then township clerk (1849). In late 1849, he also became a member of the state legislature, where he served until 1857. He was later the Macomb Co. Drain commissioner, a position he held for many years, living to be ninety. In his later years, he was the first president of the Pioneer Society, which morphed into the Macomb County Historical Society. He lived at 2002 Moravian, one of the oldest houses in the area.

Cady's Corners received a post office on July 15, 1864, and George A. Page was its first postmaster. It had a general store run by George and Amelia Wellhausen on one corner and a bar on the other. Cady's Corners was located at Moravian and Utica Roads in Clinton Township. The Miller Cemetery at Metropolitan Parkway and Utica's Section 30 is referred to as Miller/Cady's Corners.

The Cady post office closed on July 31, 1906, and the community declined thereafter.

Clifton, or **Clifton Mills**, was the site of a small mill that burned down around 1840. About 1855, brothers Neil and Hugh Gray founded Gray's Mills on the site later platted as a village. It was located at Thirty-one Mile and Mount Vernon Roads and included an inn, a mill, a blacksmith and boarded sidewalks. The one-room schoolhouse was converted into a home. A cemetery marks the area.

Columbia Corners was named for the township it was in by its first settlers, Horace Marvin and Andrew Marshall, in 1854. Its post office, with Rudolph Nemode as the first postmaster, began in 1879 and closed in 1903.

Columbus was named for Christopher Columbus and was settled during the completion of the Gratiot Turnpike in 1833. The settlement began in 1832 and received a post office, off and on, until 1904. The **Hickey** post office, which was started in 1895, was transferred to and renamed Columbus in 1909. Columbus was a stop on the Grand Trunk Railroad and had a railroad station building that is now in the Richmond Area Historical Village in Beebe Park of Richmond, Michigan. Its viability as a community died when the post office closed in 1940.

Deanville was the site of a sawdust pile so massive—and growing all the time—that the locals thought it would never disappear. The post office opened in 1874. It was at the corner of Galbraith and Brown City Roads in the southeast corner of Burnside Township in Lapeer County. It was

colorfully said to be at the foot of "Deanville Mountain," which is what the locals called the sawdust pile. Deanville was named for John C. Dean, who owned a steam mill there in the 1870s.

At first, a board shanty was used for the school, but in 1875, a new school was built. This hamlet was a spur on the Pere Marquette narrow-gauge railroad. While flourishing, Deanville exported flour, shingles and lumber. But when the post office closed in 1903, Deanville faded away.

Doyle was a railroad stop for the Port Huron and Northwestern Railroad at the corner of Boardman and Cryderman Roads by the Belle River on the border of St. Clair and Macomb Counties. It was named for train agent Charles Doyle, and there was a post office granted in 1885. When the train stopped coming in 1913, the post office closed.

East Berlin was a settlement in Berlin Township in 1851, long before its Cold War namesake achieved fame due to the Berlin Airlift of the Cold War in the early 1960s. This East Berlin's post office closed after only five years, in 1856.

Ellington was located in Tuscola County in Ellington Township at Dutcher Road and Michigan 81/East Caro Road. The Ellington post office started in 1862 and was closed in 1905.

Fargo was also known as Farrs, named for sawmill and gristmill owners A. Farr & Sons. Fargo was on Fargo Road and was a stop on the Port Huron and Northwestern Railroad. The first postmaster was Charles Farr in 1881, and the post office was open until 1959.

Fillmore was a settlement founded on July 22, 1851, and named for the thirteenth president of the United States, Millard Fillmore, who became president in 1850. Maybe if its residents had named it after a more well-known president, the community would have prospered more. The post office closed on March 17, 1859.

Fisherville in Bay County was originally known as Spicer's Corners for the man who built a sawmill here at Eleven Mile Road and Midland Road in 1866. In 1875, it was renamed Fisherville for Congressman Spence Fisher, who served as state congressman from 1885 to 1888. Fisher had lumbering operations in the area, a lumber mill that cut three-inch planks of white pine for the plank road built between Midland and Bay City circa 1875. Hoops and staves for barrels were also made there. Barrels were important commodities in a day when everything was transported by barrel, whether by ship, rail or wagon.

The post office was opened in 1892 and called Laredo. Laredo was also the name for the stop on the Michigan Central Railroad. The post office closed in 1906.

There were a few Bay County settlements with short-lived post offices. They included **Garfield**, also known as **Garfield Center**, which was named for the twentieth U.S. president, James Garfield. It had two general stores and a post office that operated briefly from 1897 until 1904. E.L. Johnson sold dry goods, dress goods, groceries, boots, shoes, chinaware, stationery and "everything else found in a first-class general store." It was located at Newberg and Eight Mile Roads. In 1910, the population was listed as fifty.

Glencoe was a Bay County sawdust city that formed around the sawmill of George Campbell in 1873. It was located on the north branch of the Kawkawlin River. This lumber town had a railroad spur leading to it. George Campbell was also the postmaster from 1876 to 1878.

Glover had a grocery store and a post office in Bay County in 1900. It was at Michigan 61 and Carter Road and was briefly served by a railroad spur. The post office closed in 1905, and by 1910, the population had dwindled to twelve. The name continued in the Glover School until 1953, when the school closed. It was located at Michigan 61 and Bentley Streets.

Hamblen, located at Seven Mile and Beaver Roads in Bay County, was named for storekeeper and postmaster Noah Hamblen, who operated the post office there from 1888 until the post office and the town expired in 1902.

Holbrook was at Holbrook and Germania Roads and had a post office that began in 1888. Holbrook had a large Methodist Episcopal church that closed in 1951. A large sand quarry was in the area. The area is near the Sanilac Petroglyphs, which were considered sacred to Chippewa tribes in the area. When the post office closed in 1905, the settlement died.

Huronia Beach was located on the west shore of Lake Huron, a private resort in St. Clair County that had a Detroit United Railway stop and a post office from 1886 to 1901. The resort closed, the train stopped coming and the community faded away.

Juhl was settled by Danish settlers Hans Tiedeman and Jens C. Juhl in 1881 in Elmer Township at Juhl and French Line Roads. It grew to have over one hundred Danish families. With a church and school, it was a farming community with a post office from 1889 until 1906 in the general store of Niels M. Smith.

Kilmanagh, at the crossroads of four townships in Huron County, had a flouring mill and a sawmill, a general store, a boot and shoemaker and a blacksmith. The post office started in 1873. The hamlet was at first called **Thompson's Corners**, for Francis Thompson, a homesteader from Ireland who became the first postmaster. Kilmanagh is an Irish word first

used to describe Shebeon Creek, which overflowed each spring. The post office closed in 1904.

Kimball was at Ditty and Dove Roads in Kimball Township, east of North Pine River Road. The land was sold about 1825, and fifteen years passed before settlement began. In 1840, Barzillai Wheeler and John S. Kimball arrived in the area and formed a town. The township was named for Kimball in 1855. The post office began in 1882, the same year the Port Huron and Northwestern Railroad started to come through the settlement. The post office was spelled "Kimbal" until 1889, when it was corrected. The post office closed in June 1908 and the community slowly diminished.

Lambs was a stop on the Port Huron and Northwestern Railroad and its successor, the Pere Marquette, when these railroads operated in the area. Around 1883, the settlement formed around the lumber and flour mill of J.A. Lamb, for whom the post office and settlement was named. The post office operated from 1884 until 1942. Although Lambs is now essentially a church and a cemetery, it has been home to a diverse range of businesses over the years, including the train depot and a John Deere dealership.

Lamotte, also known as **Newman**, was located at the corner of Decker and Richards Roads, a few miles from the Michigan 46 and Michigan 53 intersection. In 1858, the first settler was Emos Johnson. The post office was named Newman for Alexander Newman, who operated the office from

The Lambs depot of the Pere Marquette Railroad. When the train shut down, Lambs was never the same. *Courtesy of Don Harrison.*

1860 until 1864. It was renamed Lamotte for the township in 1870 and remained operating until 1906. Down Michigan 46 at Germania Street was Lamotte Corners, also known as Fox's Corners.

Laurel was in Elk Township at Marlette and Melvin Streets. In the store of Lester Billinger was a post office from 1891 to 1905. There was also the Laurel School, as well as a grocery store and other businesses.

Leitch was at the corner of Deckerville and Goetze Roads. The post office operated from 1886 until 1903. When it closed, so did Leitch.

Lengsville had a post office in 1893, as well as a general store, a cooperage (barrel making facility), a saloon, several fish stores, a school, a mill that made staves and headings, some grocery stores and a cedar post factory. It was a station on the Michigan Central Railroad in Fraser Township in Bay County. Shipped from its railway station were lumber, chicory and sugar beets.

The landowner was Leng, hence the Lengsville name. The P.L. Sherman lumber mill was the main business, located north of Linwood Road on Elevator Road between Anderson and Prevo Roads.

In 1910, the population was seventy. The post office closed in 1911, and Rural Free Delivery began soon after.

Maxwell got its start when a railway station was built for the Michigan Central Railroad in Fraser Township on State Road by the railroad tracks in Bay County. It was also a junction for the Detroit & Mackinac Railroad. It was named Maxwell for lawyer and legislator Andre Maxwell, who was a state representative in 1865. There was a hotel called the Royal Oak House; several shingle, saw- and lumber mills; a school; and a saloon. In 1875, the postmaster was William Michie, and the post office was renamed **Michie** for him in 1880. The post office closed in 1904, and the area diminished. The area was later known as State Road Crossing.

McGregor was located on Forester Road in Bridgehampton Township in Sanilac County. It was founded and named for Adam McGregor in 1859 and was a station on the Port Huron and Northwestern Railroad (later the Pere Marquette Railroad). The post office opened in 1894.

The McGregors were a large Scottish family who were successful in a stock and hay shipping business and a mercantile business, as well as in farming. Other major business folk were the sons and daughter of Hugh Campbell—they ran many of the town businesses and were active in the school and church of the community.

Between 1890 and 1920 was the heyday for McGregor when it was a trading nexus for hundreds of farmers of the surrounding area. The post office was in existence until 1961, but when it closed, it was all over for the town.

Mount Forest was a stop on the Michigan Central Railroad, Gladwin Branch, in Mount Forest Township in Bay County. In 1888, it had three general stores, a saw- and shingle mill, a hotel, a school, two hardware stores, two groceries and a blacksmith. And then the post office closed in 1895, and it began its gradual decline. In 1910, it had a population of sixty, which had decreased by 1918 to fifty.

North Williams was located at the corner of Wheeler and Garfield Roads in Williams Township of Bay County. A school was established in 1859, the first in the township, and a post office opened in 1868. The first settler was William Skelton in 1854, and the post office lasted until 1903.

Novesta was separated from Elkland Township in 1869 and gained a post office in 1874. The township, when separated from Elkland Township and in need of a name, was said to have received its name for a box in Frawley Craw's store at Centerville (Caro) that said Vesta and No, as an abbreviation for number.

W.B. Brooks started the first store in 1871, and the first postmaster was Jefferson Green. In some records, the village is shown in Sanilac County instead of Tuscola County, and in others, it straddled the county line. The town died out with the post office in 1905.

Omo is the name of a street in Lenox Township and was a village with a post office from October 16, 1897, with storekeeper Frank Will as the postmaster. The post office was closed on January 14, 1905. *Omo* was a Native American word for "prosperity," and the village was located a few miles north of New Haven Road and one mile northeast of North Avenue in Lenox Township at Omo and New Haven Roads. Omo was once a bustling community with a sawmill, school and general store. The school is still there, none the worse for wear, even though classes were last held there in the 1950s.

The town of **Palms** was founded in 1859, and it became a station on the Port Huron and Northwestern Railroad in 1880. Because of the railroad station, in 1882, it gained a post office named Palm Station with Leander Thompson as the postmaster. The name was shortened to just Palms in 1896.

Palms was located on Palms Road about a half mile west of Ruth Road in Minden Township. Primarily an Irish settlement, the parish of St. Patrick was established in 1861. A parochial school was later built. There was the Palms Hotel, the Palms Bank, a lunch counter and other businesses.

Later a stop on the Flint & Pere Marquette Railroad line, there was a depot located near the town. Palms survives in modern times mainly as a zip code.

Railroad Street was the main drag for Palms in Sanilac County. *Courtesy of the Sanilac County Historic Village and Museum.*

Plumbrook, or **Plum Brook**, was a rural post office near Plumb Brook Road from July 21, 1840, until July 6, 1863. The first postmaster of Plumbrook was John S. St. John. The community was located on Van Dyke and Seventeen Mile (now Sterling Heights) Roads. The name survives locally in Plumbrook Golf Course.

Portsmouth was located at the mouth of the Saginaw River and was platted in 1836 by Judge Albert Miller, who built a sawmill there. The post office was organized in 1836 but closed soon after, in 1840, due to slow settlement. It finally was reinstated in 1856 and stayed open until 1895. It was originally in Saginaw County but was gradually annexed to Bay City.

Rattle Run was unfortunately known more for a murder in the winter of 1909 than anything else. The small community was named for the sound of a nearby creek—on quiet evenings, the water running over its pebbly bed made a rattling noise. It was granted a post office in 1876, but it closed in 1907.

On January 5, 1909, two men discovered the door of the Methodist church swinging open. Upon investigation, they found a bizarre murder scene. The church organ was splintered from repeated blows to it and there were pools of blood everywhere. Bloody footprints were all around, but the strangest of all was what had been burning in the church stove,

A Rattle Run abandoned business on Gratiot Avenue. *Photo by the author.*

which was still warm. Upon investigation, it was obvious, due to the large piece of human skull found, that what had been burning were human remains.

The county sheriff found a bloody knife and hatchet at the scene and an eyeglass case with the name of the minister, John H. Carmichael. Six days later, after he committed suicide by cutting his own throat in the city to which he had fled—Carthage, Illinois—Carmichael was found to be the murderer of Gideon Browning.

Red Run Corners, or **Red Run**, had a post office from July 22, 1857, until September 13, 1860, with Cynthia M. Cole as the first postmistress. It was located in Clinton Township west of Garfield Road and near Sixteen Mile Road (Metro Parkway) by the Red Run River. The Millar Cemetery is located near what was Red Run Corners. South across Sixteen Mile was a large summer park that had a dance hall and pavilion.

Revere was a short-lived settlement in Beaver Township; the post office was located in a log cabin in a small log structure from 1880 until 1885.

Richmondville was located on Michigan 25 and Richmondville Road in Forester Township. The first building was a store built by Luce, Mason, & Co. in 1860. There were also two general stores, a sawmill, shipping docks, a school and a blacksmith. In 1884, a Methodist Church was built. The school, some stores and the shipping docks were destroyed in the 1881 fire

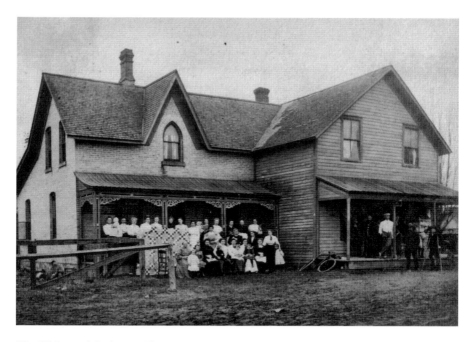

The Richmondale General Store was also a residence around 1900. *Courtesy of the Sanilac County Historic Village and Museum.*

but were mostly rebuilt. The post office had its own building, opening in 1860 and closing in 1906.

Riley Center was in St. Clair County on the Belle River. Named for John Riley, a half Cherokee Native American whose father deeded him the land in 1836, Riley's post office operated from 1867 until 1933. The post office was reduced to a mailbox, and the last business is a party store called Life of Riley.

Roberts Landing was named for its first settler, Samuel Roberts, in 1830. Samuel's sons, W.C. and W.S. Roberts, were storekeepers in the settlement, and Samuel was the first postmaster in 1869. The post office closed in 1895 although the settlement continued to be a stop on the interurban rail system until rail service ended in the 1920s.

Roseburg in Fremont Township was located on Bricker Road and the Galbraith Line. The first settlers came in 1854, and the settlement was at first known as Branagan's Corner for John Branagan, the first postmaster. The post office opened in 1876.

Roseburg prospered with four stores, a cheese factory producing six to seven hundred pounds per day, a barbershop, a pool hall, three milk stations,

a meat store, a grain elevator, a bank, a school, a church, a blacksmith shop, a train station and a hotel. The Orangemen's Hall was the social gathering place of the community where dances were held and clubs would meet. Other entertainment included boxing matches in the rear of Arnold Greenwood's barbershop.

The Bethel United Methodist Church was located in Roseburg. It was organized by William Graybiel in 1896 in a meetinghouse and the church structure was built shortly thereafter.

Sanilac Mills was also known as Pine Hills. This shadow village is located at Michigan 25 and Applegate Road in Sanilac County. The settlement grew up around a steam-powered sawmill six miles north of Lexington. Built by Captain Darrin Cole and Isaac Leuty of Lexington, the settlement had a post office established in 1850 with Leuty as the postmaster, and this was the chief post office for the whole Thumb of Michigan north of the one-time county seat of Lexington. In 1866, the name of the post office was changed to Pine Hills.

Sanilac Township was originally organized at the home of Jacob Sharpe in 1848. In the same year, a school was organized, and Uri Raymond was the teacher. The school was built about three hundred feet from the shore of Lake Huron. The mill was built on the south bank of the creek property. The sawmill serviced the heavy strand of pine trees in the area. When the post office closed in 1888, the hamlet declined.

Shabona, or **Shabbona**, was located on the corner of Shabbona and Decker Roads in Evergreen Township. The village was originally known as **Evergreen Center**. The first store was opened by Sylvester Day in 1882, and in 1884, another was opened by Mark Turner. Dr. A.W. Truerdale began practicing there in 1890.

When the post office opened in 1884, it was called Shabbona, and the village followed suit. There was also a blacksmith, an inn, a bank and the Shabbona Creamery Company.

When the railroad passed Shabbona by (instead stopping at Decker), Shabbona began its decline. The post office moved to Decker in 1915.

Sharpsville was founded at the corner of Fisher and Cade Roads in 1874 on the edge of three counties: Sanilac, Lapeer and St. Clair. It was the home of the Goodland Church. Its post office operated from 1892 until it closed in 1904, bringing a sharp end to Sharpsville.

Speaker was in Speaker Township at Michigan 19 and the Comstock Trail Road in Sanilac County and was originally called Moore's Corners, which was the name of the postmaster, William S. Moore, and storekeeper

Andrew J. Moore. The area was first organized in 1858 with the first settler, August Siche, having arrived in 1856. The post office opened in 1871. In 1884, Andrew Moore also started a creamery in the area. Speaker was known for logging bees, which were contests involving cutting trees and spinning logs on the river. The post office closed in 1906.

Snay was on Snay Road between Maple Grove and Hunt Roads in Delaware Township. It was named for postmaster Charles Snay, who ran the post office from 1896 until 1901.

Starville, or **Starrville**, was a Cottrellville Township hamlet for which Harrison Butler was the first postmaster. The post office was open from 1880 until 1905. Named for farmer David Starr, it was an interurban stop during the early 1900s. Over the years, it had many businesses, notably gas stations and small grocery stores, within its boundaries, which were Starville Road and Shea Road to Broadbridge Road. Along with general stores, blacksmiths and liveries, there was a school and a church. The church is still there, with Maple Grove Cemetery in the back, and a gas station/party store.

Souletown was a village in Huron County named for founder Charles F. Soule in 1876. It was also called Soule. It had a sawmill on Pinnebog

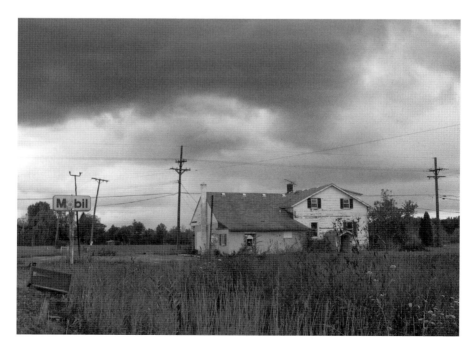

The sun sets on the former Mobil gas station of Starrville. *Photo by the author.*

VILLAGE OF SOULE - ABOUT 1890

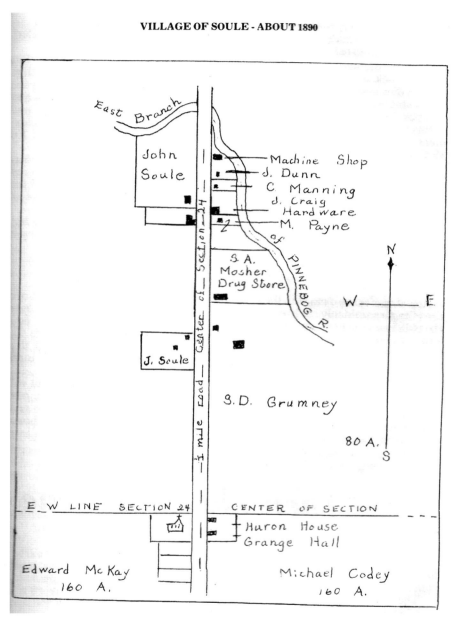

The downtown chart of Souletown shows the Huron House Grange Hall, a meeting place for the farmers of the area. *Author's collection.*

Creek, a gristmill, and a general store, and a post office was granted in 1881 with Charles Soule as the postmaster. Other businesses included a machine shop, the S.A. Mosher Drug Store, the Huron House Hotel, a church and a grange hall. A grange hall was an area where, in an agricultural community, the farmers met with agricultural representatives and learned the latest agricultural news and farming methods, swapped seeds and generally discussed local problems.

The post office closed in 1904, and the village lost its soul.

Upsla was originally supposed to be named Upsala after the village in Sweden where storekeeper John Hellman lived, but it was shortened by the post office in 1889. The Swedish settlement was in Williams Township in Bay County on the north branch of the Kawkawlin River. It began to diminish as a village when its post office closed in late 1904.

Urban was at first known as **Davis Corners**, for postmaster Simon P. Davis in 1876. In 1883, the post office and village were renamed Urban. It was located on Michigan 19 and Urban Road in Sanilac County. The post office closed in 1906, and the village faded away.

Valley Center was on the corner of Galbraith Line and Shephard Road in Maple Valley Township, and the first settler was Frank LaCass in 1854. A post office had Franklin Allen as the postmaster from 1876 until 1882, and the post office was briefly called Beckett for the first town supervisor, John H. Beckett, who held the post from 1857 until 1872. The post office was named Valley Center in 1882 and, this time, remained open until 1940.

Watertown was in Watertown Township on Michigan 19 and was settled in 1851. The first school was erected in 1867, a sawmill in 1882 and the first store in 1883. The post office opened in 1895. The town faded away when the post office closed in 1905.

Wickware was in Greenleaf Township at Cass City Road and Leslie Road, named for Alfred Wickware, the first postmaster in 1882. The hamlet was first settled in 1858 with Stephen Greenman the first settler. In 1879, Hugh Jordan built a sawmill, and a blacksmith joined the community in 1883. The post office closed in 1906.

9

PICKING UP THE BUILDINGS AND MOVING TO THE NEXT TOWN

Most of the vanished settlements are now gone without a trace, absorbed into a larger city, abandoned to nature or simply lost to oblivion, with the residents not aware that the area they live in was once a named community. However, the most dynamic vanished villages have left reminders of their existence behind—a long-vacant business building or two, sidewalks mostly taken over by vegetation, foundations or old railroad tracks that remain in areas of some former settlements.

With today's green movement, it is often pointed out that refurbishing or repurposing a building that is still in sound condition is much more ecological (as well as economical)—saving the cost and labor of not only constructing a new building but also demolishing the old. But this knowledge was well known in the 1800s and early 1900s, too. Often, when a village or community would start to dwindle, the residents would move the buildings to the closest larger settlement.

Many buildings from long-gone towns can be found in nearby settlements. Ironically, sometimes the buildings would be moved to a community that would die faster than the old one. This was basically the case when business owners in Lum moved their buildings to King's Mill, which became a lost town quicker than Lum.

Berne, also known as **Berne Junction** and **Berne Corners**, was in Caseville Township in Huron County and was founded about 1878. It was named for Berne, Switzerland. Gaining a post office in 1882, it closed permanently about 1904. It was a stop on the Saginaw, Huron & Tuscola Railroad as well as the Pere Marquette.

The Washington House Hotel was located here, as well as a livery. Starting in 1884, the village was gradually moved south to the more thriving village of Pigeon.

In St. Clair County, **Brockway** was a village named for Lewis Brockway, who settled there in 1840. A lumbering village, it had a gristmill and sawmill. A nearby village was known as Brockway Center, named for the township. This village changed its name to Yale, for the Ivy League college. The post office for the original village opened in 1852 but closed in 1907 when the village was bypassed by the Pere Marquette Railroad.

Most of the buildings of the original Brockway village were put on skids and moved to nearby Brockway Center, now called Yale. The town was moved over the corduroy road that has now morphed into state highway Michigan 19.

Pinnebog was a lumber town. This hamlet was located on the border of both Hume and Meade Townships because, at one time, it was divided by the "stage road" or road the stagecoach ran down.

In 1844, the first settler of the area was Walter Hume, known as the "Daniel Boone of Huron County." He built first a log cabin and later a trading post and inn. He was an equal-opportunity trader, trading with both Native Americans and white settlers.

The name was originally **Pinnepog**, which was Chippewa for "partridge drum," after the name of the nearby river. But five miles north on Saginaw Bay was another settlement also calling itself Pinnepog after the river that had formed a short time after the first one. This didn't appear to be a problem until the 1860s, when both communities applied for a post office. The U.S. Postal Service told one of them to change its name, so the people of Pinnepog number two made the big plunge and changed the town name to Pinnebog (said to mean "a high-sounding and dignified way of saying pine bog"). This really wasn't much of a change, with the probability of just as much mail mix-up as before. But the citizens of Pinnebog felt this was the best they could do and wouldn't budge on changing even a few more letters in their town's name. So it became Pinnebog on the Pinnepog River, and the other settlement subsequently changed its name to Port Crescent. Both sawdust cities were destined to have their heydays for as long as the lumber lasted and then fade away. Pinnebog did last longer as a village. It was the recipient of some of Port Crescent's buildings when the sawmills there closed after the 1881 fire and after the lumber was depleted.

Pinnebog had a school (with an enrollment of 120 students "with an average attendance of 60") and stores that sold dry goods, groceries,

hardware and agricultural implements. Wagner & Brothers operated a blacksmith business. There was also a flour mill, a feed mill, a cheese factory, a physician, a hotel called the McLain House and a Methodist church. Lewis Gerard was the proprietor of a dry goods and grocery establishment there.

If you want your town to prosper, perhaps it wouldn't be a good idea to name it after a place that was destroyed in a disaster like Pompeii, an ancient Roman city that was destroyed when the Mount Vesuvius erupted in AD 79. While **Pompeii** in Michigan's Gratiot County wasn't destroyed by volcanic eruption, it didn't have a long life as a town.

Pompeii was first settled in 1854 in Gratiot County by Joseph B. Smith and was called "Joe B.'s" for him. Smith built a hotel on the state road to Ithaca. A tavern and a few more stores followed. He was the first postmaster in 1856. By 1860, the village was anticipating a railroad going through.

When the railroad finally came through, it did so a couple miles away. So the whole village was moved a mile and a half south in order to be on the Toledo, Saginaw & Muskegon (now the Grand Trunk) railroad line in 1867. The actual buildings were picked up, put on rollers and hauled by teams of horses. At the border of Fulton and Washington Townships a new town was platted in 1867. To the new town was added a train depot and a stone and steel grain elevator that stood for over one hundred years; it was razed in 1992. As many as twenty-five or thirty trains went by each day with at least five or six making stops.

The new Pompeii prospered and became a stagecoach stop on the St. Johns to St. Louis route in addition to being on the train route. The Methodist Episcopal Church had been moved from its former location brick by brick and took three years to rebuild; it was completed in 1890. A one-room schoolhouse was completed by 1891. In 1897, Dr. Bert Hall began to practice and built a sixteen-bed hospital. The hospital began as a four-room bungalow and expanded from there. The only state bank in the area was opened in 1910.

Around 1920, the new Pompeii began to decline. In 1930, the hotel closed, as did the hospital in 1935. The new state highway was built farther away, and in 1957, the trains had slowed to one or two a day, causing the depot to close. In 1960, the school closed, and the children now take a bus to Ithaca schools.

Port Crescent is a notable ghost town of Huron County, at one time a village of seventeen blocks and more than five hundred inhabitants. Originally Pinnepog, the town changed its name to Port Crescent for the shape of the inlet on Saginaw Bay on which the town was situated.

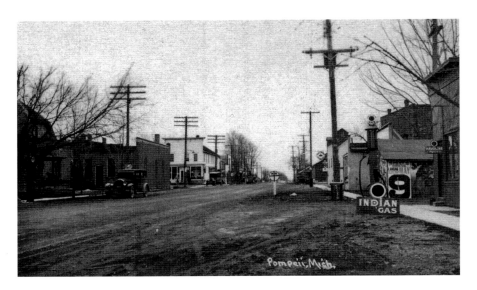

Pompeii moved the whole town to be by the railroad. *Courtesy of Don Harrison.*

Port Crescent had two of everything: two sawmills, one on each side of the river; two salt plants; two blacksmiths; and two hotels. It also had a cooperage (barrel making facility), a gristmill, a wagon factory, a pump factory, a boot and shoe factory, a brewery, several stores, a depot, a telegraph office, a few taverns and a roller rink.

Port Crescent was an entry port for many German families coming from New York and a stop on the Pontiac, Oxford and Port Austin Railroad.

You would think with a setup like this, the town would continue to prosper, especially with the brewery and roller rink. But the town began to decline after the lumber ran out in 1881. A lot of its lumber was burned in the Port Huron Fire of 1871, although it was spared a lot of destruction in the Thumb Fire of 1881 because of a change in wind direction. But by that time, most of the lumber in the area, especially the desirable white pine, had been cut. Port Crescent hung on a while longer when a new industry arose, the exporting of white sand, which was used in the manufacture of glass. The cooperage in town made barrels to ship the sand.

Finally, its post office closed in 1902, and Port Crescent, formerly Pinnepog, began its slow death.

Many more businesses literally moved out of town as people moved buildings to new places. The "Company Mill" was moved to Grindstone City. Houses were disassembled and then reassembled in Bad Axe, Pinnebog

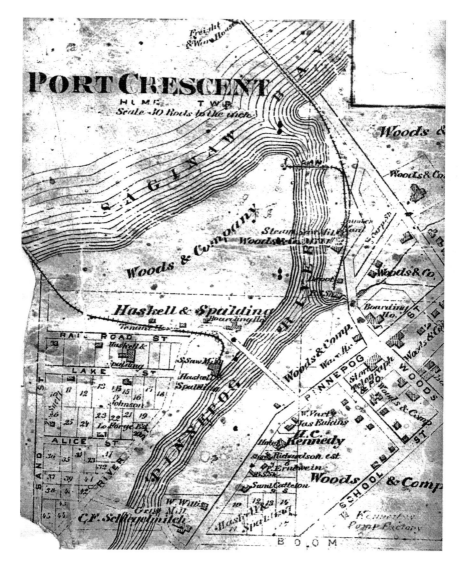

The map of the lost city of Port Crescent highlights its prominence on the Pinnebog River. *Author's collection.*

and Port Austin. The All Saints Church, built in 1884, was moved to Kinde in 1907 by the Lutherans.

By 1936, the last business moved away and the village became a ghost town for over twenty-five years. In the early 1960s, the area was converted into the Port Crescent State Park.

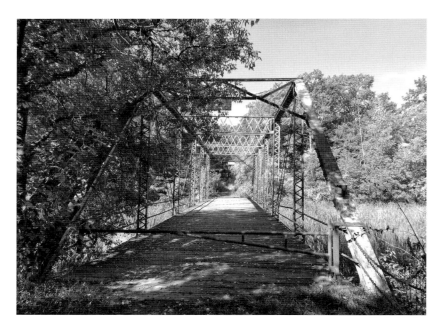

The great steel bridge across the Pinnepog River is the last great remnant of Port Crescent. *Photo by the author.*

Like many lost communities, the Port Crescent Cemetery is one of the last remnants of the community. This cemetery is now deep in a wooded area with only a small dirt trail leading to the burial place. *Photo by the author.*

Tyre on the Cass River in Section One of Austin Township in Sanilac County was about a half mile north of the Bay City–Forestville Road. Its name was derived from the ancient city of Tyre in Palestine, as chronicled in the New Testament of the Bible in Matthew and Acts. The Hebrew word *tyre* relates to rock, which was fitting for the rock-covered village located on a rocky surface. The village was named by the Alexander Soule family, the earliest recorded homesteader in Tyre, who had two hundred acres.

Tyre was a station on the Pere Marquette Railroad, and the first store was a log building built by Richard Collins. The post office, with John Getty as the first postmaster, began in 1862 in the store owned by James O'Sullivan. It was located at the corner of the old Bay City–Forestville Road and the Huron County line. Prior to the establishment of rural routes from Tyre in 1904, the mail was carried on a stage with stops at Freidberger, Cumber and Wickware before it reached its final stop at Cass City.

The railroad that came to Tyre was at first a narrow-gauge railroad of the Port Huron and Northwestern line. It was spearheaded by Henry McMorran, who had a large enterprise called the "Company Farm" that mostly dealt in hay, which was baled and loaded directly onto railroad cars brought in on a spur from the main line.

In 1855, Tyre had a general store run by Floyd Dominick (where the post office was located), a bar operated by Ira Fishe, a grain elevator belonging to the Snover Grain Company and Fred Weltin's Electrical, Plumbing and Appliance Service. Tyre was hit by the 1871 and 1881 fires but rebuilt after both disasters.

One of the last remaining businesses of Tyre was the general store. *Photo by the author.*

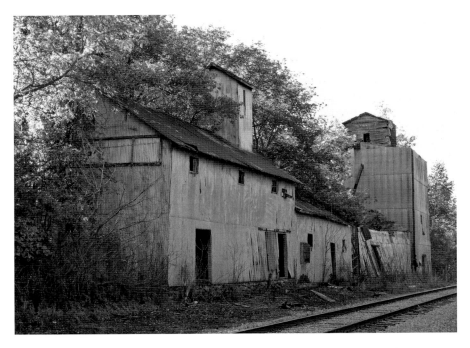

The train station of Tyre was a large structure used for hauling both freight and passengers. *Photo by the author.*

The railroad tracks were a half mile from the corner where Tyre originally started. So the town then began to expand toward the tracks. A plank walk was laid for the entire distance as both sides of the streets began to grow. From the 1880s through the 1890s, Tyre had five general stores, one of them operated by Alfred Gunning, for whom the area was sometimes called Gunning Mills; two drugstores; a grain elevator; a gristmill; a hardware store; four sawmills; two blacksmiths; a wagon maker; a harness shop; a stone quarry; a coffin making business; an egg storage business; seven doctors; and a hotel called the Hamilton House and one called the Tyre House, also run by Alfred Gunning.

The two schoolhouses of **Ubly** included one a mile south called the Thomas school. The other one was a mile east on the Huron County line and was called the East Fractional School. The first church was built on the county line across from the Tyre Cemetery.

In the Tyre Cemetery are buried the poisoned remains of the Sparling family. The nearby town of Ubly is where the Sparlings were given arsenic from 1809 to 1811. The poisoned victims include John Wesley Sparling,

fifty-three, and three sons: Peter, twenty-five; Albert, twenty-three; and Scyrel, nineteen. The town doctor, Dr. John MacGregor, was convicted of the three murders (the victims were his lover's husband and children), but he was pardoned without explanation by Michigan governor Woodbridge Ferris in 1916. MacGregor was appointed prison doctor at Jackson State Prison, where he had previously been an inmate.

In 1894, Tyre was down to two general stores—of those, one closed in 1954 and the last one in 1978. As Tyre began to decline—you guessed it—the buildings started to be moved to nearby Ubly. In spite of the area's decline, the post office was open until 1964.

SOME TOWNS DON'T DIE, THEY JUST FADE AWAY

S ome towns prosper and grow while some do not. Some lost towns do not have an obvious reason for their decline like a gigantic fire, a post office closing or the death of their main industry. Some places just slowly diminish until one day it isn't there anymore. As towns fade away, sometimes they linger in their dying phase. There are many towns that have lingered on in a diminished state, such as Sanilac County's Deckerville, Decker, Carsonville and Melvin. And some are gone without a trace.

This is what happened with **Disco**. It had a gradual decline until one day, the Disco road signs disappeared. Disco was settled in the early 1830s when settlers, mostly from New York, cleared land and built log cabins on the corners of Sections Nine, Ten, Fifteen and Sixteen of Shelby Township. They originally called this the "Utica Plains." A village was platted in 1849; Isaac Monfore, John Noyes and Chauncey Church owned the land. The first Methodist church was built in 1827. The townspeople hired Alonzo M. Keeler to supervise their high school, the Disco Academy. The town and the school took their name from the Latin word for "to learn" (though by some accounts, it was intended to be a shortened version of "District of Columbia").

Erected in 1850, the building continued in the service of high and primary education until 1864. At this point, the lower floor was used by the school trustees, and the upper floors were used by the religious societies of the neighborhood (the Methodists and later the Congregationalists). The village and the post office followed suit, also using the name Disco.

The post office operated from May 5, 1854, until July 31, 1906. In 1856, the Disco Academy had 137 students, growing to 154 students in 1857. The original building burned in 1880 and was replaced. Disco Academy declined with the advent of the state public school system, and the old academy building became a restaurant. Some sources place the main part of the town at Van Dyke between Twenty-five and Twenty-six Mile Roads. Besides the academy, Disco boasted a wooden bowl factory, a feed mill, a cider mill, two general stores, a harness shop, a paint shop, a hotel called the "Halfway House," a planing mill and even a local physician.

In those days, Twenty-four Mile Road in Shelby Township was called French Road. In order, going south down Van Dyke Road, was the Disco Academy and then Brown's Wagon Shop, which made buggies, wagons and cutters. After four houses, there was a blacksmith shop and then the farm of Judson Monfore. Across the street from Disco Academy was the Switzer Store, which sold groceries and more. After the Switzer Store were the post office and then more houses. Then there was John Crow's iron business followed by Matt Murrays's general store. Above the store was the Gleaner's Hall, where dances and suppers were held. In the back was another blacksmith shop. (When Murrays's building burned down, it was the biggest fire ever for Disco and the beginning of the decline of the Disco village.)

On the corner of Van Dyke and French Roads was a large hotel that was also a stagecoach stop in the earlier days of the village. Later, the Switzers purchased it. Mr. Switzer was the owner of the grocery store, and his wife was a teacher at the Disco Academy. The Detroit Creamery, which purchased from all the farmers in the area, was at Twenty-three Mile and Van Dyke Roads. Not far down, alongside Van Dyke Road, was a racetrack. In 1922, Van Dyke Road was paved with cement, and railroad tracks were added.

Another business Disco had that prospered even during Prohibition was a distillery. This was why Disco was also known as Whiskey Center. Besides whiskey, a half barrel of beer was obtainable at the distillery for eight dollars.

Even though it was never the site of an actual disco, Disco had a few other entertainment establishments during Prohibition. An establishment later called McClenaghans, and even later known as Ichabod's Bar, was south of Twenty-four Mile Road on Van Dyke and served as a blind pig called the Yellow Canary at the time.

The name Disco was continually in use in some form as the name of businesses in the Van Dyke and Twenty-four and Twenty-five Mile

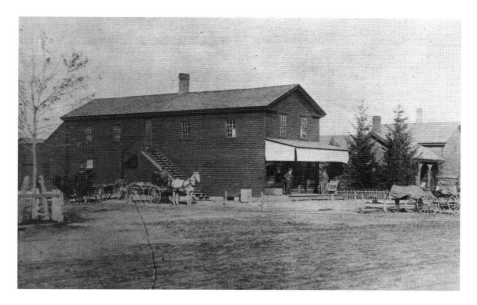

The Switzer Grocery Store of Disco was the longest-lasting business of this lost town, staying open until the mid-1990s. The building was torn down a few years after it closed. *Courtesy of Bob Mack.*

Road area—as evidenced by the shopping center called Disco Plaza and the Switzer grocery store building, which survived until the new millennium—and was used on many maps of the area until recently.

Alcona was at first a fishing town in Alcona County in 1858. The name was devised by Henry Schoolcraft from a Native American word for "beautiful plain." William Hill was a fisherman known as the "Commodore of the Cove" and first settled the area. By 1867, it had grown enough to warrant a post office. It had also become a lumber town with pine trees being cut and floated down the river since there was no railroad leading to the area at that time. It was not until 1895 that the Detroit & Mackinac Railroad reached Alcona. Therefore, most of the logs were shipped by water on schooners or barges towed by tugboats. The logs were moved to the water by horse-drawn sleighs and logging wheels.

Oddly, there was no sawmill in Alcona, strange for a lumber town. But there were two general stores, two hotels, a lumberman's supply warehouse, a harness and blacksmith shop, a saloon and boat docks servicing the over 250 people who resided there. Around 1880, the lumber died, and the town began a slow decline. The post office closed in 1903, and by 1933, the population was down to one.

Amelith was a mile and a half from the settlement of **Frankenlust** in Bay County. It was settled by Frederick Koch, the father-in-law of the founder of Frankenlust, Reverend Sievers. It was named for Koch's homeland in Bavaria. Cheese maker John Berger was the only postmaster, from 1894 until 1901.

Arn, also known as **Arn Station**, was a sawmill settlement in Merritt Township at Nolet and Kinney Roads in Bay County. It was a station on the Michigan Central Railroad. The post office started in 1877 and was run by storekeeper Archibald Meson. It had a school and a few other businesses. When the post office closed in 1904, it also lost its stop on the railroad and faded away.

Berkshire was on Michigan 46 and Berkshire Road in southeastern Custer Township in Sanilac Township. Two of the largest farms in the town were the Sanilac Stock Farm—home of the Berkshire Post Office, which was formed in 1890—and the Island Farm, which had a large boardinghouse that served as the residence of many of its workers. A breed of cattle was named for the settlement.

There was a train stop in Berkshire, and in fact, a famous serious train accident happened on the tracks leading there. The town had grain elevators and sidewalks that were the last traces of the settlement. The post office closed in 1914.

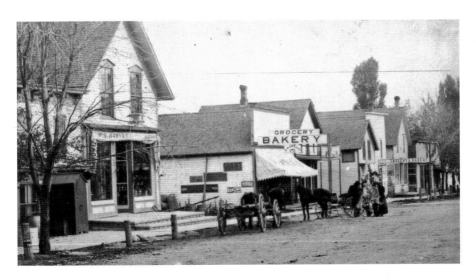

In this Carsonville photo, the shed at left contained kerosene and gasoline. It is 1913, and horse and buggy are still the main transportation. *Courtesy of the Sanilac County Historic Village and Museum.*

Carsonville was once called **Hall's Corners** after Silas C. Hall, who built a log store there in 1853. Hall was also the first postmaster when it was given a post office in 1857 with the name of **Farmers**.

In this later picture of Carsonville, automobiles make their appearance. The sign on the right says "Feed Grinding." *Courtesy of the Sanilac County Historic Village and Museum.*

The main street of Carsonville after a snowstorm. The bank and a bakery can be viewed in this 1900s photo. *Courtesy of the Sanilac County Historic Village and Museum.*

Arthur Carson moved from the Black River area, where he had a hotel and a side business selling alcohol to Native Americans. He moved to the Hall's Corners area and built a store and hotel in 1864. He enlarged it in 1872 and then built a grain elevator in 1880.

The town was renamed for leading citizen Carson in 1884, when the Pere Marquette Railroad came through. It was incorporated as a village in 1887.

After Arthur Carson's store, the next store was built in 1868 by Uri Raymond & Co. Uri Raymond founded one of the oldest continuing businesses in Michigan, Raymond Hardware of Port Sanilac. The store's motto is still "anything and everything." Uri Raymond's house, built in 1870, is now the Raymond House Inn, a Victorian bed-and-breakfast in Port Sanilac. Uri Raymond was one of the leaders of Sanilac County. He had a hand in the incorporation of the county, was a pioneer in the Sanilac County educational system and was one of the first teachers. He also started the county's first newspaper, the *Bark Shanty News*.

Another major store in the area was John Ryan's in 1881. The Exchange Hotel was built by John Farley in 1880. There was also the Carson House and Livery Stable. A five-ton-per-day-capacity cheese factory was built in 1881.

In 1911, it was major blow to the community when the block of the Ruttle Building burned down. As other businesses left, new ones failed to move in and the village began its long decline.

A snow-filled scene in Davis, Michigan, around the 1900s shows a thriving business block. Most, if not all, of these businesses are long gone. *Courtesy of Don Harrison.*

Davis, a settlement of Ray Township, was originally named Brooklyn (also spelled Brooklin). Because this name was already taken in Michigan, the settlement was renamed Davis in 1876 in honor of Reverend Jonathan E. Davis. The first postmaster was also named Davis: Bela R. Davis. The post office operated from March 9, 1876, until August 31, 1910.

At its peak in the 1940s, Davis had two grocery stores, two gas stations, a church, Davis Hardware, a barber/beauty shop, cleaners, a tile factory, a grange office, a two-room schoolhouse, insurance and other offices, a Masonic Temple and a cemetery.

Prior to 1876 (when the settlement was called Brooklyn), there were two blacksmiths, a hotel, a general store, a sawmill, a cooper, a church, a school and a cemetery. The "Plank Road Mill" manufactured planks for the Romeo Plank Road. Davis was/is located at Twenty-seven Mile and Romeo Plank Road in Ray Township. It is still a viable community, with the Masonic Lodge still operating, as well as a party store, pizza place and electric business. The Davis Baptist Church is there, and the cemetery has recently added a new chain link fence.

Decker still retains a hint of infamy as the site of the farm where Timothy McVeigh and Terry Nichols stayed intermittently before committing the 1995 Oklahoma City bombing.

When the last bar in town closes, you know your town is in trouble. The Decker Bar closed around 2006. *Photo by the author.*

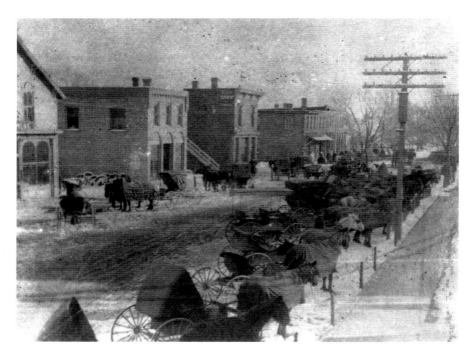

Above: Deckerville is pictured in the horse-and-buggy days during a 1903 snowstorm. *Courtesy of the Sanilac County Historic Village and Museum.*

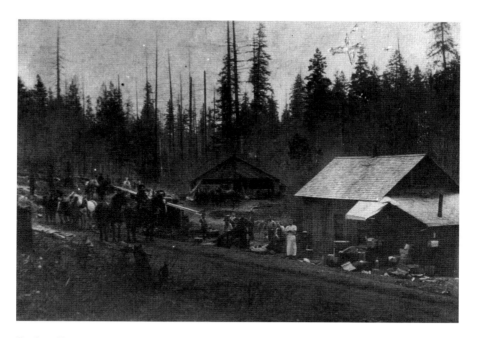

Deckerville was a logging community as this pre-1881 fire photo illustrates. Deckerville was hit hard by the fire and afterward became more of a farming community. The fire had cleared a lot of the land. *Courtesy of the Sanilac County Historic Village and Museum.*

Opposite, bottom: The New Meat Market can be seen on the left in this Deckerville photo—just so you don't accidently go to the old one. Does that mean the meat is fresher? *Courtesy of the Sanilac County Historic Village and Museum.*

At various times, Decker had a dance hall; several stores, including a hardware store; a terminal for the Michigan Sugar Beet Company; and a train depot, the remains of which can be seen behind an old fuel oil distribution center. The depot was last used by the Detroit, Caro & Sandusky Railroad.

At one time, Decker also had a bowling alley and a bar, the remains of which is one of the few reminders of Decker besides the post office (which serves the whole area), the LaMotte Township Hall and the over one-hundred-year-old Decker United Methodist Church.

Decker was located on Church Street along Decker and Snover Roads in the center of LaMotte Township. The first postmaster was storekeeper Clinton J. Beers in 1899. (Another community nearby was started by Clinton J. Beers and called **Noko**. The post office operated from 1896 to 1904.) The Deckers were local pioneers and large landowners. The Decker family was also the namesake for Deckerville. Charles Decker was a large lumber

proprietor. The sawmill of Jay Decker sawed more than one million feet of lumber back in the day.

Decker began to decline when the railroad died out. Its last gasp was when it was featured on the *Nightline* TV show as part of a profile of the Oklahoma bombers. The bombers Timothy McVeigh and Terry Nichols hid out on a Decker farm that later got searched in relation to the tragedy. *Nightline*'s Ted Koppel met locals in the Decker Methodist Church to discuss the area.

Since the Decker Post Office also serves the surrounding area, including the lost town of Hemet, Decker is one of the few lost towns where the post office survived but the town died.

Charles Decker was another of the Decker family to make his living from selling lumber. He was the namesake of the town and started his lumber business in Marion Township in 1865. His son Martin Decker was first postmaster of the post office named Deckerville in 1870. The Deckerville Post Office was moved from its first location on a state-cut trail with a general store and camp. The original post office was named State Road with Andrew Wright the postmaster in 1868.

Deckerville was platted in 1870 and incorporated as a village in 1893. It is still a viable community with a library and fire department, but the main street and town identity is more of that of a small farming community than a village.

Many of the early Sanilac settlers would clear the land for farming and, while doing that, would shave shingles out of pine wood that could be sold and used to live on while clearing the land. Shingles were even used as currency. In some ways, the devastating fires of 1871 and 1881 were beneficial—they cleared the land for farming.

Once land was cleared, red raspberries would be planted, and then, during July and August, one of the main professions of Sanilac County would be "berry picker."

Deckerville has become a shadow town, but it is still there.

Five Lakes was at one time a named community in Mayfield Township, Lapeer County, near the Sanilac County border, but now its most enduring presence is as the name of a rest stop. Named for its nearby lakes, it was first settled in 1855 by the Piper & Thompson Company, which built the first sawmill there to take advantage of the white pine in the area. Soon to follow was the Sage, Ferry & Lee Co., as well as a sawmill owned by A.B. Royce. Another business was the inn of William G. Stone, which was also the location of the post office in 1869. The post office was briefly called Asa from 1874 to 1878. After the white pine was gone, the village soon followed.

In the 1930s, Forester was still struggling along after the timber was gone. *Courtesy of the Sanilac County Historic Village and Museum.*

The Tanner House Hotel was one of the most well-known Forester businesses. Pictured here in the 1920s, the hotel has many cars parked in front, most of which were the popular Ford Model T. Lake Huron can be seen in the distance. *Courtesy of the Sanilac County Historic Village and Museum.*

This structure in Forester was W.H. Miller's grocery, previously owned by the Smith family. It was also the town post office and telegraph office. *Courtesy of the Sanilac County Historic Village and Museum.*

Forester was first settled in 1849 by Alanson Goodrich and was on Michigan 25 and Forester Road in Forester Township. The first general store came in 1851 and the post office in 1858. As a lumber village, it had a sawmill to cut the pine timber and some stores, churches and hotels.

The Lake View Hotel was operated by James Hartshorn starting in 1858, and another hotel called the Tanner House was erected by Edward Smith in 1871.

In 1870, a Methodist church with a tall steeple dominated the skyline. In 1954, it was hit by lightning and burned to the ground.

In 1913, the docks were destroyed in a storm, continuing the decline that started in 1907, when the post office closed and the lumber began to run out.

Forestville continued the Sanilac County tradition of failed villages with the word forest in the name. It was in Forester Township on Michigan 25 and Charleston Road in Delaware Township. In the beginning, Native American trails went through the area.

In 1855, the settlement had a shingle mill and two general stores. A school was started in 1855, and a post office started in 1856. The Forestville docks had warehouses that stored coal and produce waiting to be shipped

Geyer's Furniture Store in Forestville at what was then the corner of Cedar Street and Eighth Street in 1903. *Courtesy of the Sanilac County Historic Village and Museum.*

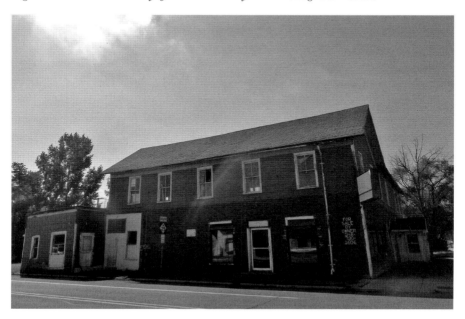

The furniture store in Forestville as it looks today on what is now a state highway. *Photo by the author.*

out on Lake Huron. The Potts Dock extended out into Lake Huron for over 250 feet.

The village was destroyed in the 1871 fire but was rebuilt. It was saved by villagers and bucket brigades in the 1881 fire. In 1883, it lost one of its largest businesses when the Saxonia Mill of Amos Wood was moved to Port Sanilac. The people of Port Sanilac raised $500 to induce Wood to move to their village. Forestville was never the same, although it is still there.

Mikado was in Alcona County and was originally called **Bruceville** for founder Daniel Bruce. Bruce had been a surveyor in the area and liked the locale, so he purchased a number of acres. Desiring to start a town, he first built the Bruce Hotel for lumbermen, charging just $1.50 per night. He also successfully petitioned the Detroit & Mackinac Railroad to build tracks to the area, helping to finance the addition with $360.00 of his own money. Other businesses followed, including a cheese factory, a railroad depot, a church, a blacksmith shop, a farm implement store, a bank and a grain elevator.

Mikado received a post office in 1886. Because there was already a post office with the name of Bruce, the name Bruceville was rejected. Instead, it was named Mikado, for the Gilbert and Sullivan play that was popular at the time. It was incorporated as a village in 1906, but as it began to decline following the Great Depression and World War II (the Japanese name Mikado was very unpopular while the United States was fighting Japan during the war), it was unincorporated and is no longer an official village.

Lum in Lapeer County was organized in the 1880s by Wallace Huntley and William Tierney. When the founders wanted to name it Arcade Center, the name was refused by the postal service since there was already another town in Michigan by that name. So Huntley had it named Lum after Colonel Charles Lum, the commander of Detroit's Light Guard Armory in the Civil War under whom he had served.

Many people thought Lum had been named for *lum*ber because that is what grew the town originally. In 1884, the Pontiac, Oxford and Northern Railroad came through and built a depot in Lum and hauled out lumber and farm products. Once the railroad came through, a grain elevator, a hotel, a general store, a creamery, a town hall, a saloon and several more stores were built shortly thereafter.

In 1904, the town got telephones and a bank. Electric power was provided by Harvey Van Wagoner with a generator that was shut off nightly, plunging the town into darkness at 10:00 p.m. An explosion almost destroyed the depot in 1909, but it was rebuilt. The old depot's remaining wall was used in the

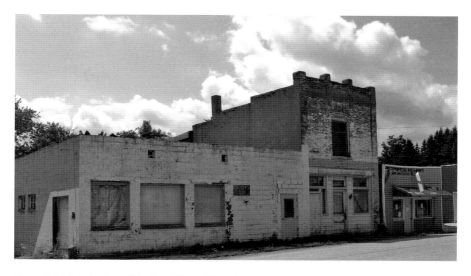

One of the last business blocks of Lum (that didn't get moved to Kings Mill) has been long vacant. *Photo by the author.*

Lum in Lapeer County has all but disappeared, except for its sign. *Photo by the author.*

construction of a new schoolhouse. The town of Lum was also an agricultural center and one year shipped out over one hundred boxcars loaded with potatoes. A pickle plant that had its own brass band opened in Lum.

In the early 1920s, Lum tied into a regional power grid and strung streetlights and electric lines throughout the town.

The end was getting closer when, in 1922, the "Polly Ann," as the local railroad was called, greatly curtailed service to Lum and the bank closed. The now unused hotel was converted into a store as most of the other businesses

left or closed. The partly burned mill was hauled up the road to another town, **King's Mill**, and the post office closed. By 1940, more than half the people had left, and there were more deserted buildings than occupied ones. More of the buildings were moved to King's Mill.

The town briefly saw new life as Lumco, a company making crankshafts and camshafts, moved to Lum and employed over fifty people. A golf course was built nearby. But the hardware store closed and was torn down (not moved), as were many other buildings.

Lupton was a village in Rose Township of Ogemaw County on the Rifle River named for Emmor Lupton, one of many Quaker families who came to the area in the 1880s. There are still Amish in the area. Lupton moved from Ohio with his wife, three sons and three daughters. In 1889, they built a sawmill and shingle mill.

One of Emmor's sons, Levi Lupton, was a Quaker minister who was also a postmaster in Lupton (originally called **Lane Heights**) in 1881. The town was a stop on the predecessor to the Detroit, Bay City & Alpena Railroad, the Detroit & Mackinac. In 1893, a spur from National City (called Emery Junction) that went to Rose City was the beginning of the railroad through the area. When it became the Detroit, Bay City & Alpena Railroad, a depot was built for Lupton. The railroad would bring the mail to the area from then on. Before that, like many rural post offices, the mail had been delivered by stagecoach, horseback, walking and even sleigh over the ice. From the train station, the mail would be taken via a hand-drawn pushcart with iron wheels to the post office, which, for many years, was in the general store of Joshua Rakestraw.

One of the duties of the postmaster was to issue money orders for cash. The first money order issued in Lupton was to schoolmaster Lawrence Dunlap in 1899. Besides the school, Lupton at its peak had a blacksmith, a grocery store, a hardware store, a general store, a small hotel, livery stables, a meat market, a millinery, lumber and real estate offices, a shoemaker and a drugstore.

Although Lupton grew into a medium-sized village, it had been platted to be much larger than it ever became, with large streets of twenty square blocks to accommodate a streetcar line. A pamphlet was printed extolling the virtues of Lupton, including a thirty-five-room, three-story hotel that was never built. In 1928, the railroad went out of business, and the mail began to be delivered by truck.

The Graceland Ballroom was a notorious dance hall frequented by members of the Purple Gang and the site of a 1936 shootout. It was

built and operated for a number of years by "One-arm" Mike Gelfand. The Graceland Ballroom was built in the late 1920s and burned down on December 21, 1981.

The Purple Gang had a notorious ranch in the area named the South Branch Ranch. It was basically an elaborate hideout for the Purple Gang in a rural area. The ranch was one of the biggest in Michigan and had barns as large as airplane hangars, as well as an airstrip. Other amenities included an Olympic-sized pool, a dance hall and an indoor horse riding area. There was a hunting area, servants' quarters and a junkyard. The buildings had secret tunnels and hidden rooms. The area was searched during the disappearance of Jimmy Hoffa. It was seized by the IRS for taxes in the early 1970s and lay vacant for years until it was torn down and Green Briar Golf Course built on the site.

Marcellus was an early Macomb County site that was part of a farm owned by Joseph Hayes in 1819 and located in Clinton Township at Gratiot Road; the village was platted by Green Freeman in 1838. Although it had a sawmill, a store, a blacksmith shop and a few homes, it did not prosper and had died out by 1890.

Meade had Stewart Taylor as the first postmaster of its rural post office in 1838. At that time called "Vienna," it was renamed for Civil War general George Gordon Meade on November 28, 1863, and operated until July

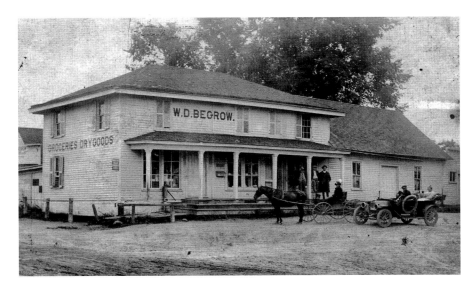

The general store of W.D. Begrow was one of the first businesses in Meade. *Courtesy of the Ray Township Historical Society.*

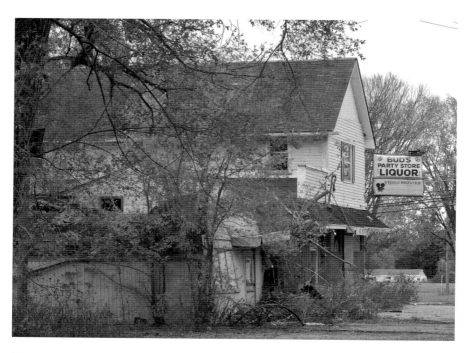

The remains of the general store can be seen right before the last business block of Meade was razed in 2014. *Photo by the author.*

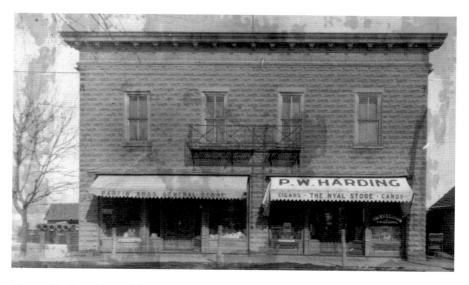

The Parkin Bros. General Store and P.W. Harding's drugstore are pictured in Melvin, Michigan. *Courtesy of the Sanilac County Historic Village and Museum.*

31, 1906. During the 1870s, it was also known locally as the "Crawford Settlement." It was at one time near a small airport. Meade has pretty much disappeared nowadays. The last "business block" of Meade has been torn down, including the remnants of the last businesses—a party store and Quonset hut barbershop. Meade Cemetery and a few street signs are all that's left of Meade. It was located at Twenty-six Mile Road and North Avenue in Macomb County.

In the 1960s, Meade was the location of a recording studio, Sound Inc. It had a few "Northern Soul" recording labels attached to it. The studio could also press vinyl records, which are now highly prized by collectors the world over. The studio was considered a "one stop" since an artist could record a song and have it cut to vinyl right away. Owned by rockabilly pioneer Johnny Power and others, one of the groups to record at the studio was the Capreez, who had a popular local single called Roseanna.

Melvin was a sociable place—the first business was a saloon in 1862. In 1869, a drugstore was opened by Alex Donaldson. It was located on Galbraith Line and Melvin Roads in Speaker Township.

Given a post office in 1874, Melvin was a station on the Port Huron and Northwestern Railroad. In 1884, it had, besides the saloon, a hotel, two stores, a gristmill and a sawmill. In 1907, Melvin was incorporated as a village. Now with not much more than a post office serving the immediate area, Melvin is little more than a crossroads village.

Middleton was in the middle of the state but was actually named for George Middleton, who settled there in 1885. Middleton was given a station on the Toledo, Saginaw & Muskegon Railroad (which became the Grand Trunk) in 1886. In 1887, it received a post office and was platted and recorded as a village by William T. and George S. Naldrett, George Flanks and John Resseguie in 1887. William Naldrett also ran a feed mill and a man named Harry Phillips a drugstore. Although the town showed early promise, it failed to meet its early potential.

Milton was a station on the Grand Trunk Railroad in Chesterfield Township. Located at roughly Twenty-four Mile and Bates Roads, near Gratiot Road, Milton had the first post office in Chesterfield Township. It was started by town namesake Robert O. Milton in 1837. The post office was in his house and was called the "New Haven Post Office." This post office was moved closer to New Haven with Alfred D. Rice establishing a new Milton post office thereafter. Milton also had a post office from January 10, 1856, to July 15, 1904, with Edmund Matthews as the postmaster. Milton boasted a school; Baptist, Congregational and Methodist churches;

a physician; a blacksmith; and a couple taverns, the last of which survived until 2004.

A notable village with a notable citizen was **Mount Vernon**, which was named for George Washington's estate, a natural choice since the settlement was located in Washington Township. William A. Burt, a surveyor, became its first postmaster on December 19, 1832. The post office was renamed Mountvernon on April 8, 1894, and operated until July 5, 1905. William Burt was also an inventor (of the first typewriter in 1828 and a solar compass in 1836), millwright, state legislator, justice of the peace, circuit court judge and writer. He built the "Octagon House" on Twenty-eight Mile Road. The site of one of his houses, now in Stony Creek Metropark, has a historic marker.

Businesses in Mount Vernon included a general store that sometimes served as an inn, a cooper, a re-weaving place, sawmills and a greenhouse. There was also a railroad station, and the village had a constable. The Fangboner Buggy Shop was a large business that made buggies, wagons and cutters. They also operated a blacksmith shop, which competed with the other blacksmith shop, operated by Jeremiah Cole. Still a third blacksmith in the area was Stewart Metz

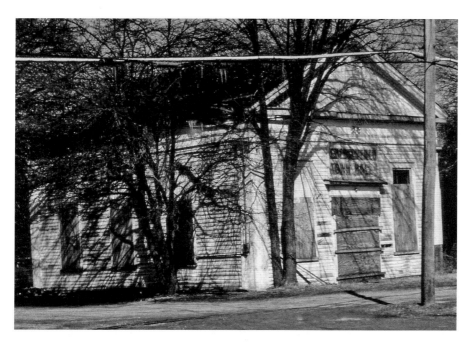

The Congregationalist Church of Milton was later sold to Chesterfield Township, which used it as a township meeting place during the 1920s through the 1950s. *Courtesy of Bob Mack.*

who was located not far away—at the corner of Dequindre and Inwood Roads. Another Mount Vernon business building had a cider mill in the basement and a woodworking shop on the first floor. Mount Vernon also had a watch and clock repair shop and a "hops" house, where the proprietors grew hops and "other things." Wonder if the constable knew about the other things?

There was also a school and Methodist and Baptist churches. Farming was the chief industry. Dennis Soule, a farmer, specialized in constructing windmills.

The small community was ravaged by smallpox from late 1875 to early 1876. Many of the graves from the cemetery at the still extant Methodist church were from this epidemic. Mount Vernon was located in Washington Township at Mount Vernon and Twenty-eight Mile Roads. The Capuchin Retreat Center is currently located a half mile north of Twenty-eight Mile and is the only business now in the area.

Peck had its start when Nathaniel VanNest built the Globe Hotel in 1859 in Elk Township in Sanilac County. He added the first store in 1868. Peck was given a post office in 1858, and the settlement was named for the Michigan secretary of state George W. Peck. Peck had been appointed by Governor Epaphroditus Ransom in 1848.

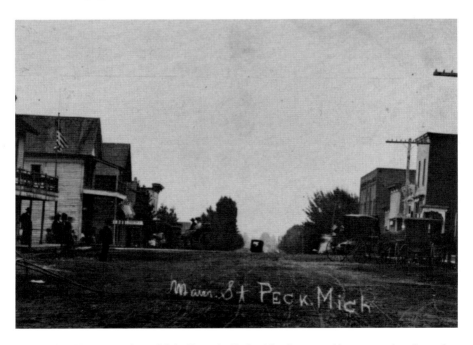

This early 1900s scene shows Main Street in Peck with a horse and buggy coming down the road. *Courtesy of the Sanilac County Historic Village and Museum.*

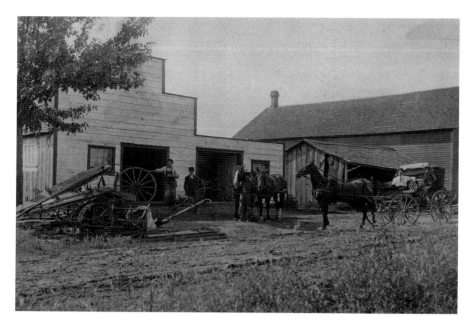

The Peck blacksmith shop was also a buggy repair shop. *Courtesy of the Sanilac County Historic Village and Museum.*

At one time, Peck had four general stores, two hotels and two drugstores. Although it was incorporated as a village, it has been losing population and businesses. But even for a town sometimes referred to as "Speck" for its small size, there had to be a blacksmith.

Preston Corners/Prestonville came about in 1826 when four hundred acres of government land in Shelby Township was purchased by Ira and Deborah Preston of New York. They settled on the land in 1827 and built a sawmill (reputedly the first in Macomb County) and later a picket fence factory. The sawmill operated for forty years, until the late 1870s.

There was also a Prestonville School. In 1881, the Prestonville School had an enrollment of sixty-four students. The school closed in 1954 and was converted to a private residence. Preston was located at Twenty-five Mile and Schoenherr Roads. There is a Prestonville Cemetery in Shelby Township at Twenty-five Mile in "Section 2." A bronze plaque was erected commemorating Preston Corners in 1926.

Quinn came into being when, on December 10, 1869, Theodore Kath became the first postmaster for this rural post office located in Clinton Township on Gratiot past Sixteen Mile Roads. The post office operated until September 15, 1873.

The cemetery is one of the last remaining traces of the prosperous village that was Prestonville. Please note that no loitering is allowed in the cemetery. *Photo by the author.*

In the area where Prestonville once stood, the old schoolhouse has been remodeled into a residence. *Photo by the author.*

The Frog Mountain School is the last trace of a community known as Ray. *Photo by the author.*

The organization of the Twelfth Michigan Infantry was begun under Colonel Francis Quinn at Niles in September 1861. The Quinns built a new brick house on Gratiot Road in 1881, and the settlement was named for him. Quinn became one of the first communities of freed black people in Macomb County.

Ray was a rural post office in the center of Ray Township that opened on May 1, 1827, with Reuben R. Smith as the first postmaster. Not to be confused with the Ray Center post office, it operated until June 25, 1868.

In Macomb County, a number of settlements started in Armada Township but just didn't last. There was **Sacket's**, named for Lemuel Sacket, who was the first postmaster and a tavern owner. This rural area had a post office from March 27, 1833, until July 3, 1856, and was also known as Armada Corners and Sacket's Corners. Not far was **Salem**, a small community with a post office in Armada Township from February 1832 until March 18, 1842. Leonard Lee was the first postmaster. Another lost town in Armada Township was **Scottsville**. The first postmaster of Scottsville, also known as **Scotch Settlement**, was Urial Day. The post office operated from March 19, 1852, until April 27, 1859.

Silverwood in Lapeer and Tuscola Counties is a mere shadow of what it once was. Though the town was originally a large lumbering center, many of the residents stuck around and turned to farming once a lot of the lumber was gone. Potatoes and beets were shipped out of town by rail. Sometimes the crates of beets would be stacked up for hundreds of yards waiting to be shipped.

This town has had four different names. When it first became a stop on the Pere Marquette Railroad in the 1880s, it was known as Silver Creek. When the railroad first came through and it was evident that a post office would be needed, the townspeople, in applying for a name, asked for the post office department to give them something easy to remember. So they were given the name "Easy." By 1890, the name had become Rollo for a reason no one could remember, and finally, in 1892, the town's name was changed to Silverwood for the white pine trees in the area.

Some of the Silverwood businesses over the years included the Kildau and the Bradshaw Cheese Factory, a lumber and shingle mill, two jewelry stores, a funeral parlor, a grain elevator, brick makers and the Hotel Easy. By 1895, there were two blocks full of stores. In the early 1900s, Silverwood had over four hundred people, a Ford dealership and three gas stations.

Nowadays, a bar that moved into the old bank building and a party store are the chief remaining businesses of the once vibrant Silver Creek, Easy, Rollo and Silverwood.

Waldenburg, or **Waldenburgh**, was located around Romeo Plank Road and Twenty-two Mile Road and began with a sawmill. An influx of German settlers in the 1830s turned it into a farming community with a Lutheran church (still in existence on Twenty-one Mile and Romeo Plank Roads), a school, a tavern, a wagon shop, a general store, a blacksmith, a hardware store and other businesses. The cemetery behind the Lutheran church on Twenty-one Mile Road has many of the original settlers buried there. The settlement was named after Waldenburg, Germany.

The Macomb post office was moved to Waldenburg on March 29, 1860, and lasted until September 15, 1906. The last hardware store, Stiers Hardware, was in business until the mid-2000s. The building that Stiers was in was originally across the street from where it ended up, and it served as a dance hall for the Waldenburg community. It was moved in 1903. Next door to the hardware store was the Waldenburg Tavern. There was also a North Waldenburg and South Waldenburg, located, surprisingly enough, north and south of Waldenburg on Romeo Plank Road.

The Lutheran Church of Waldenburg is one of the last remnants of the once viable German community. *Photo by the author.*

North Waldenburg was located at Twenty-three Mile Road and Romeo Plank while South Waldenburg was located at Hall Road and Romeo Plank. South Waldenburg, also called **Bobcean's Corner**, was known for its tavern. A park near Twenty-three Mile Road and Romeo Plank Road has been named Waldenburg Park in honor of the settlement.

TOWNS THAT DIED WHEN THE RAILROAD STOPPED COMING

Where the railroad went could make or break a small settlement. Getting bypassed by the train could be the death of a community. Michigan had many small lines running back and forth through the state, but the main two were the Grand Trunk Western Railroad and the Pere Marquette Railroad. Eventually, most of the smaller lines were absorbed by Grand Trunk Western Railroad (later shortened to Grand Trunk Railroad). Almost as big was the Port Huron and Northwestern Railroad, which was absorbed by the Pere Marquette Railroad and then eventually died out.

Berville was named for Berlin Township and was a stop on the Pere Marquette Railroad. The land was first purchased in 1835 with settlement actually beginning in 1840. The post office operated long enough to celebrate its centennial. It opened in 1862 and closed in 1962. Berville was also known as **Baker's Corner**.

The depot was preserved and is presently in a park in nearby Allenton. The downtown still has surviving businesses, including a hotel, a bar, a grill, a few trucking and construction businesses, a church, a Lions Club and a German grocery store.

Elmer was at West Sanilac (Michigan 46) and Ubly Roads in Moore Township and was settled in 1866 by Walter Hyslop. It was named for Colonel Elmer of the Civil War but also known as just "the Corners." Another name was Cornstock for a corn stock nailed to a tree. The post office, which operated from 1876 until 1906, was known as Elmer City.

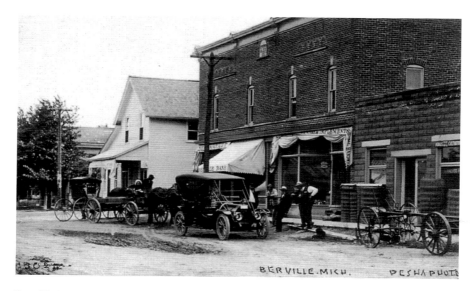

Berville is seen in this pre-1910 photo. Berville had its own post office for over one hundred years. It closed in 1962, and this shadow village has just a few businesses left. *Courtesy of Don Harrison.*

The schoolhouse was built in 1869, and the village was incorporated in 1870. At one time, there was the Moffit store, which was a large two-story building with living space on the second floor; the Sheldon store; a creamery; a blacksmith; the township hall; a Methodist church that proved so popular it had to expand; a post office building; and two hotels, one called the Elmer House in 1882. At the corner of Michigan 19 and Michigan 46 were the stockyards. Dr. Wallace, the physician, had his own building.

Elmer had two big disappointments in its existence. One was when it was considered as a site for the Sanilac County seat but lost to Sandusky, and the other was when it feuded with nearby Snover for a railroad stop on the Handy Brothers Railroad coming from Sandusky. Elmer lost the railroad stop to Snover in 1910 and began to decline from that point. The Handy Brothers Railroad operated until 1938.

Fostoria in Tuscola County got its start when Michigan governor Henry H. Crapo purchased most of the pine forestland in the area and then got the Pere Marquette Railway to run its line through the area. The foreman for his lumber business was Thomas Foster, and he had the settlement named for him in 1881. Before that, the area had been part of the Chippewa hunting grounds. Before the Chippewa drove them away, the Sauks were the chief Native American tribe in the area. Fostoria only briefly had a post office,

from 1882 until 1883. About two miles to the south was Hurd Corner, the original town.

A school was built at the corner of Foster and Goodrich Roads, and the first teacher was Alvin Cody, who was a first cousin of famed Wild West Show proprietor, Buffalo Bill Cody. A gristmill run by "One Eye Kelly" with "Old Julia," the mule, across the street from the school was the main attraction at recess.

There was a newspaper, the *Fostoria Star*; a buggy and harness shop; and a hotel-salon next to the buggy shop. There was also a blacksmith, barbershop, drugstore, grocery store and general store. East of town was a sawmill.

Most of the settlers who were not lumbermen were farmers. They farmed the land after first going through the rough work of clearing it. Potatoes were a big crop, mostly shipped to Flint via the train. When the train stopped running, Fostoria died out.

Freidberger was a vanished village at Freidberger and Cumber Roads in Sanilac County. Its post office began in 1888. It was a stop on the stagecoach line before it became a stop on the Pere Marquette Railroad line.

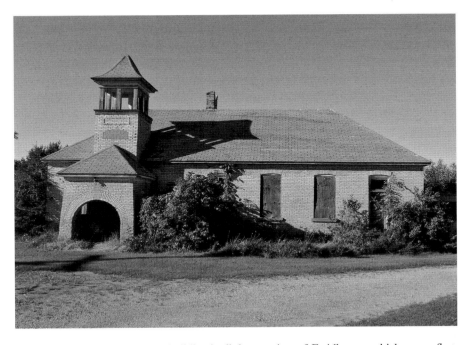

The municipal building/school building is all that survives of Freidberger, which was at first a stagecoach stop. Later, Freidberger became a railroad stop, but when the train went out of business, the town did, too. *Photo by the author.*

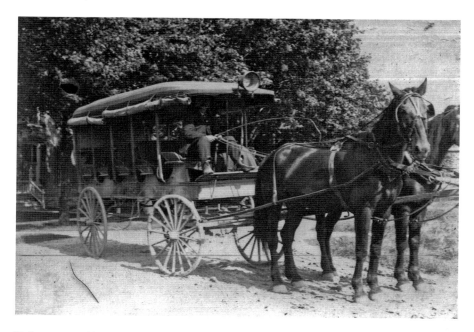

Before automobiles, and even before the train, stagecoaches, such as the Croswell one pictured here, helped fill the transportation needs of the small towns. *Courtesy of the Sanilac County Historic Village and Museum.*

Opposite, top: In Minden City, passengers wait for the train alongside a stagecoach there to pick up passengers. Stagecoaches were the taxis of their day. *Courtesy of the Sanilac County Historic Village and Museum.*

The remains of Freidberger include a municipal building/school, a church, a few foundations and a few outbuildings to mark its one-time presence as a village.

When the Pere Marquette Railroad stopped running through the area, Freidberger began its decline until only the church remained.

Many communities, including Freidberger, were stops on a stagecoach line that ran in Sanilac County *before* the railroad came. When the railroad stopped coming, the stagecoach didn't start back up—automobiles had taken over, and many places that existed mainly as stagecoach and train stops no longer had a reason to be there.

Juniata had a hotel named Kelley's Tavern in 1864 and was also called **"Kelley's Corners."** In 1859, Charles Frenzel opened a harness buggy shop. There was also a blacksmith, a sawmill, two stores, two churches and a prosperous business of shipping ties and bark by train. Juniata was

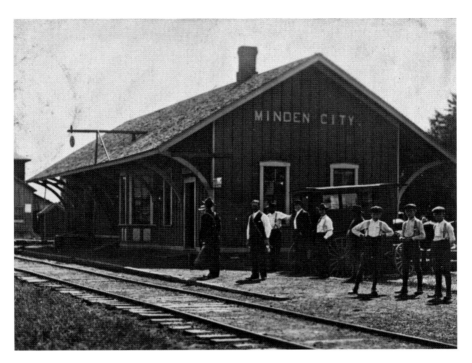

On Minden City's main street, the State Savings Bank can be seen on the left. *Courtesy of the Sanilac County Historic Village and Museum.*

also a stop on the Port Huron and Northwestern Railroad with a station built in 1882. When the train stopped coming Juniata declined.

Minden City was founded by Philip Link in 1855 and named Minden City for his native Minden, Germany. The first store was opened in 1859 by Alfred Gunning. Gunning sold the store in 1861 to William Donner, who opened the Minden Post Office in 1862.

The village was incorporated in 1862. A crossroads village, it is in Sanilac County on Forestville Road and Cass Street. In 1880, it was given a stop on the Pere Marquette Railroad in 1880.

The town had a brick maker, drugstore, millinery, school, undertaker and harness shop in the early days, among other businesses. The pride of Minden City was its seventeen-piece band. Charles Shraeder was the son of Minden City's wagon maker and had a business selling farm machinery.

Ray Center was located in the southern part of Ray Township, and Ray Center's post office was opened on February 13, 1846, with Wilson W. Millar as the first postmaster. The post office closed briefly in 1872 and was then reinstated until 1906. The first land purchase in the area was made by Reuben R. Smith in 1824. First named Rhea, after the Latin name of a river in Europe, the town name was later changed to Ray, which is still the

This Ray Center gas station was from the 1920s. *Courtesy of Ray Township Historical Society.*

The same building has been repurposed as an antique shop in the present day. *Photo by the author.*

township name. Its location was at the intersection of Twenty-nine Mile Road, Hartway Road and Indian Trail Road on the north branch of the Clinton River.

One of the main businesses was the Shafer Mill. It went into decline when the railroad passed it by, instead going by Armada and Romeo.

GIFT RECEIPT

Barnes & Noble Booksellers #2830
14165 Hall Road
Shelby Township, MI 48315
586-247-7416

STR:2830 REG:003 TRN:9066 CSHR:Steve K

Lost Towns of Eastern Michigan
9781626197787 T1
(1 @ VR.HH) VR.HH G

Thanks for shopping at
Barnes & Noble

101.37A 12/14/2015 04:29PM

CUSTOMER COPY

With a sales receipt or Barnes & Noble.com packing slip, a full refund in the original form of payment will be issued from any Barnes & Noble Booksellers store for returns of undamaged NOOKs, new and unread books, and unopened and undamaged music CDs, DVDs, vinyl records, toys/games and audio books made within 14 days of purchase from a Barnes & Noble Booksellers store or Barnes & Noble.com with the below exceptions:

A store credit for the purchase price will be issued (i) for purchases made by check less than 7 days prior to the date of return, (ii) when a gift receipt is presented within 60 days of purchase, (iii) for textbooks, (iv) when the original tender is PayPal, or (v) for products purchased at Barnes & Noble College bookstores that are listed for sale in the Barnes & Noble Booksellers inventory management system.

Opened music CDs, DVDs, vinyl records, audio books may not be returned, and can be exchanged only for the same title and only if defective. NOOKs purchased from other retailers or sellers are returnable only to the retailer or seller from which they are purchased, pursuant to such retailer's or seller's return policy. Magazines, newspapers, eBooks, digital downloads, and used books are not returnable or exchangeable. Defective NOOKs may be exchanged at the store in accordance with the applicable warranty.

Returns or exchanges will not be permitted (i) after 14 days or without receipt or (ii) for product not carried by Barnes & Noble or Barnes & Noble.com.

Policy on receipt may appear in two sections.

THE FIRST NATION BUILT
THE FIRST VILLAGES

The first inhabitants of the thumb were the Woodland Indian tribes of Native Americans who came to the area following the last major ice age, around fifteen thousand years ago. They were mostly nomadic, but in their travels, they often came back to the same places annually. Every year, they would visit the sacred site of the Sanilac Petroglyphs. In the autumn, they would go to the maple trees along the trail from Sebewaing to Caseville in Huron County, near the border with Bay County and on the shoreline of Lake Huron. There is a township in Lapeer County called Indianfields Township, near Caro, where they would plant and cultivate acres of pumpkins, beans, corn and squash.

The Native Americans of the Thumb were mostly of the Chippewa tribe and refer to themselves as the "First People." They had villages they would go to, year after year. When they buried their dead, they would build mounds with artifacts of the deceased buried with him or her. These mounds have been found on what are now the present-day sites of Peck, Forestville, Port Austin, Caseville, Bay Port, Ubly, Palms, Kate Chai Islands, Argyle and Deckerville. Many of these mounds have been determined to be over two thousand years old. Arrowheads and other artifacts found have been estimated to be over seven thousand years old.

Another place on the annual wanderings for the Chippewa was the ceremonial grounds on the White Pigeon River. In the late 1830s and early 1840s, Christian missionaries built schools for the First People at this spot.

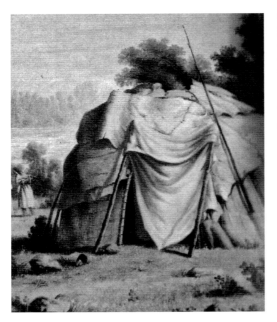

The domains of the Woodland Indians suited the nomadic ways of the various tribes. A frame would be covered with bark and furs to use for shelter. These were easily assembled and moved to the many areas where the First People had villages in the Michigan Thumb area. *Courtesy of Library of Congress.*

The Chippewa built dome-shaped shelters that were covered with birch bark strips. All of it was easily moveable and easily transported, but each structure could comfortably house six or seven people when assembled. The canoe frames, which they built out of white cedar wood, were also covered with birch bark.

Major Chippewa settlements included a large village in the vicinity of the present-day Port Crescent State Park in Huron County, also the site of the ghost town Port Crescent. Other Huron County Chippewa villages include one in the area of Port Austin, in the vicinity of present-day Gallop Park, and another on the Point Charity peninsula, a three-mile-long peninsula now known as Sand Point that later had a lighthouse nearby.

Junctions of rivers were popular sites for Native American settlements. A large Native American village was located at the junction of the Flint and Saginaw Rivers. The "Black River Indian Village" was near Port Huron. A small village was located at the mouth of the Sebewaing River and a larger one farther on at Sebewaing Creek.

Two more large Chippewa villages were in Lapeer County, one at Potter's Lake and the other at the shore of Nepessing Lake. (The later settlers weren't sure how to spell Nepessing, spelling it "Nipissing," but experts later said it was originally Nepissing. After many road signs and maps were produced spelling it Nepessing Lake and Nepessing Lake Road, the spelling stuck.)

The Lake Nepessing Indian Village has one of the most tragic stories of all those from the pioneer days. Most of the First People tribes did not have any immunity to the diseases brought to the Michigan area by the new

settlers. Cholera, diphtheria and smallpox hit the Native Americans much harder than the Europeans, who had been exposed to the diseases. The Lake Nepessing Indian Village was especially hard hit, losing over three hundred members of the tribe to smallpox.

In Macomb County, a large Native American village was visited by one of the earliest settlers, Robert Robertjean. It was on the Au Vasse River off Lake St. Clair and, after the Treaty of Detroit, was one of the regions that the Chippewa were confined to, from 1807 to 1835. The area is presently a township office for Chesterfield Township and a historic village for the Chesterfield Township Historical Society.

In 1807, the First People tribes signed the Treaty of Detroit at White Rock in Sanilac County. General William Hull was the negotiator, the same person who was later court-martialed after the War of 1812 for surrendering Fort Detroit to the British without firing a shot. Hull was taken in by a ruse perpetrated by Tecumseh in which the same Native Americans circled the fort while doing war dances and making lots of noise over and over again so that Hull thought the attacking group was much larger than it actually was.

General Hull was forced into retirement (and only rescued from being executed by a pardon from President James Madison), and General Lewis Cass became the territorial governor. As such, he took over the treaty negotiating. Unfortunately, his style of negotiation included generous helpings of whiskey to the First People, not that the terms of the treaty were understandable to them anyway.

The first treaty Cass negotiated included the 1819 Treaty of Saginaw, where Cass met around two thousand Chippewa leaders on the banks of the Saginaw River. Negotiating tools included 662 gallons of whiskey. This resulted in the Chippewa giving away six million acres of land for a small amount of money (around $10,000 for the Treaty of Detroit). The giveaway included their prime hunting land—which was a very sad blow since the Chippewa were primarily hunters and trappers, although they did some farming. The Treaty of Detroit and the Treaty of Saginaw resulted in the whole of the Michigan Thumb being opened to settlers.

The next treaty that Cass (who the Native Americans called "Big Belly") negotiated was the 1821 Treaty of Chicago. This time, he upped the whiskey amount he took with him to 932 gallons. Through these treaties, all the local Native Americans were eventually required to relocate to Kansas or Michigan's "Indian Country," Isabella County. Many Native Americans were relocated here while others fled to other safe enclaves, including Canada's Walpole Island.

Lewis Cass did some great things, including convincing settlers through his explorations that Michigan wasn't the mosquito-infested swampland it was reputed to be. However, cheating the First People out of their land through the use of whiskey was definitely his low point.

Bay County had a number of Native American villages. Most of these villages were known by the names of their chief. **Na Bob Ish** was a village at the present site of Essexville, near the mouth of the Saginaw River. **Chick a Mee** was located at the mouth of the Saganing River, and in the Kawkawlin River area was the village of **Bokowtondon**. On the Cheboyganing River was **Puh Wuh Guh Ning**. On Charity Island was the village of **Sha We Na Gun**. Near the Wenona Beach area were the villages of **Neh Way Go** and **Ke Wa Ke Won**.

Tobico was a station on the Detroit & Mackinac Railroad but had earlier been a Chippewa settlement known as **Pe To Be Goong**, which means "little lake by the big one." The shortened version was Tobico. The Chippewa desired the area due to its trees, underbrush and grass and used it as a hiding place during their war with the Sauks. The settlement was west of the present site of Bay City State Park.

Bo Ko Ton Don was an Indian Reserve on the northwest bank of the Kawkawlin River in Bay County.

Pinconning or **Pin Nee Koning** was a Chippewa settlement at the mouth of the Pinconning River. A white man, Louis Chappell, operated a water wheel here in 1850. After the first white settler, L.A. Pelkey, arrived, the Native American village relocated. Pelkey was a fisherman who later opened the first hotel, the Michigan House.

George Van Etten and William Kaiser were lumbermen who built a sawmill and platted out a one-hundred-acre settlement in 1872. A company store and post office were set up, the post office starting in 1873. Two railroads running through the area helped it become an incorporated village in 1887 (and a city in 1931).

Native American villages had the distinction of being Michigan's first lost villages. What will be the next lost town in Michigan? Keep your eyes open because you never know where they once existed!

BIBLIOGRAPHY

Curwood, James Oliver. *Green Timber*. Garden City, NY: Doubleday, Doran and Company, Inc., 1930.

Des Autels, Frederick W. *The Township of Redford: Its Heritage and History*. Detroit, MI: Redford Historical Society, 1975.

Eldridge, Robert F. *Past and Present of Macomb County, Michigan*. Chicago: S.J. Clarke, 1905.

Hennig, Sister Marciana. *Serving You: Post Offices of Michigan*. Lansing: State of Michigan, 1977.

Leeson, M.A. *History of Macomb County, Michigan*. Chicago: M.A. Leeson & Co., 1882.

Maki, Craig. *Detroit Country Music*. Detroit: Wayne State University Press, 2014.

Nelson, June. *It Happened Here One Spring*. Self-published, 1968.

Pall, K.M. "The Amazing History of Macomb." Lecture series, 1999.

Raymond, Oliver. *Shingle Shavers and Berry Pickers*. Self-published, 1976.

Remer, Deborah. *If This Is Hastings…Then Where Is Hog's Hollow?* Rochester Hills, MI: Rochester Hills Museum, 1990.

———. *Lost Villages, Small Towns and Railroad Stops in Oakland and Macomb County*. Lansing, MI: Michigan Pioneer and Historical Collection 1874–1912, 1990.

Romig, Walter. *Michigan Place Names*. Detroit: Wayne State University Press, 1986.

Scott, Gene. *Michigan Shadow Towns: A Study of Vanishing and Vibrant Villages*. Livonia: Michigan Humanities Council, 2005.

BIBLIOGRAPHY

Sharp, Odeal LeVasseur. *Place Names and Ghost Towns of Bay County*. Bay City, MI: Museum of the Great Lakes, 1974.

Spring, Kathleen. *Small Towns, Detroit's Crown*. Huntington Woods, MI: Spring Times, 1996.

Wakefield, Larry. *Ghost Towns of Michigan*. Vol. 1. W. Bloomfield, MI: Northmont Publishing, 1991.

———. *Ghost Towns of Michigan*. Vol. 2. Holt, MI: Thunder Bay Press, 1995.

Wallace, Jean. *Sanilac County Ghost Towns and Historical Photos*. N.p.: self-published, 2004.

INDEX

ABOUT THE AUTHOR

Alan Naldrett was an insurance agent for many years and soon had a wall full of sales awards and plaques. But as soon as his main topic of conversation was actuarial tables and all his friends had more than adequate insurance coverage (and so were all avoiding him), he decided it was time for a change. After he turned fifty, he put his bachelor's degree from Michigan State to use by going back to school. He acquired a couple of master's degrees in library and information science and archival science. He took a few anatomy, physiology, microbiology and other relevant courses and became a medical librarian. He then spent many years as an academic librarian chastising college students about their literary choices and inadequate APA style. Along the way, he rediscovered an interest in writing and history, which, interestingly enough, led to writing about history. He attempted to justify this by becoming a member and sometime vice-chairman (even though he claims to know nothing about vice) of the local county historical commission and also the local library board. Though he has written five books and many historical articles for newspapers, magazines and newsletters, he still spends an inordinate amount of time playing with the F Street Blues, a blues band that plays a lot of rock songs.

Visit us at
www.historypress.net
..
This title is also available as an e-book